PRESTEL

SIGHTLINES

ART
From Impressionism
to the Internet

Klaus Richter

Prestel

Munich · London · New York

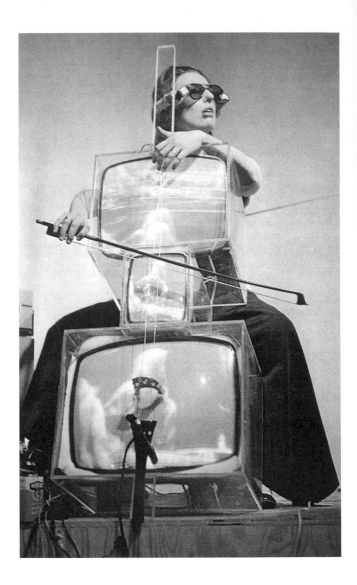

Nam June Paik, *TV-Cello*, 1971, see p. 119.

For Uta,
Charlotte, Leonard and Jonathan
Thanks to Wolfgang

A

Abakanowicz, Magdalena (b. 1930) Polish figurative sculptor who employs fabrics. → p. 144.

Abramović, Marina (b. 1946) Yugoslav-born Body and Performance artist. → p. 116.

Absalon (1964–83) Israeli-French installation artist.

abstract art Approach to art that rejects figurative and representational forms. → p. 150.

Abstract Expressionism Over-arching term covering the non-geometric abstract art that developed around 1945, which allowed for greater expressiveness. → p. 92–7.

Abstraction-Création Association of geometric artists founded in Paris in 1931. → p. 82.

Academic Term denoting artworks (especially in the 19thC–early 20thC) that conform to the dictates of the art schools, the *académies*.

Acconci, Vito (b. 1940) American Body artist. → p. XX.

acrylic Non-water-soluble paint in which the binder is not oil but an artificial solvent.

Action art *see* **Performance art.**

Action Painting Method of painting not simply with brushes, but using spattering, dripping, and pouring techniques. → p. 94.

Adams, Ansel (1902–84) American photographer. → p. 64.

Aeropittura Italian Futurist painting movement (late 1920s–1930s) representing aircraft and flight.

Agam, Yaacov (b. 1928) Israeli-born Op and Kinetic artist who worked mainly in Paris. → p. 120.

Albers, Josef (1888–1976) German-American painter of Abstraction-Création, Op art, and Bauhaus. → p. 76, 82.

Alechinsky, Pierre (b. 1927) Belgian Abstract Expressionist painter belonging to the Cobra group. → p. 102.

alla prima Painting technique where, once the paint is applied, the surface is subsequently neither overpainted nor retouched.

all-over painting Abstract painting technique pioneered by Pollock whereby the whole surface of the work is covered uniformly in abstract motifs, the center being no more important than the edges.

American Scene Painting Realist style of painting in the United States from the 1930s to early 1940s. → p. 84.

Analytical Cubism *see* **Cubism**.

Andre, Carl (b. 1935) American Minimalist sculptor. → p. 128.

Andrea, John de (b. 1941) American Superrealist sculptor. → p. 124.

Anquetin, Louis (1861–1932) French Symbolist painter. → p. 36.

Antonakos, Stephen (b. 1926) American Minimalist neon sculptor. → p. 128.

Appel, Karel (b. 1921) Dutch Abstract Expressionist painter and member of Cobra. → p. 102.

Armitage, Kenneth (b. 1916) English Abstract Expressionist sculptor. → p. 96.

Arnautoff, Victor (1896–1979) American Scene painter of urban subjects. → p. 84.

Arp, Hans (Jean) (1887–1966) German-French Dada and Surrealist painter and sculptor associated with Abstraction-Création. → pp. 80, 82.

Art Brut Works produced outside art schools, galleries, groups, etc., by untaught artists, which became recognized as art in Paris after the Second World War. → p. 98.

Arte Cifra Italian figurative art-grouping of the 1980s. → p. 136.

Arte povera Description of an art form that exploits the "poverty" of materials such as cloth, rock, soil, twigs, newsprint, etc.

Art Informel Movement which began in Paris in 1945. This painting style—which forms part of European Abstract Expressionism—does not obey compositional rules and is marked by gesturalism and free and spontaneous expression. → p. 94.

Art Nouveau Florid late 19thC decorative style. The equivalent term in German is Jugendstil. → p. 40.

Arts and Crafts movement English-based social and aesthetic movement founded in 1882 around William Morris, which strove to combine art and craft and to reform the design of manufactured goods; an influence on Art Nouveau.→ p. 40.

Ashcan School American 1920s realist painting grouping keen to depict the everyday life of the urban population.

assemblage Technique based on the addition of three-dimensional objects (often refuse; *see* **combine painting**) into a plane picture. An extension of collage, the form became widespread in the 1950s. → p. 110.

Atget, Eugène (1857–1927) French post-Pictorialist photographer of cityscapes. → p. 64.

Auerbach, Frank (b. 1931) German-English painter associated with New Figuration. → p. 134.

automatism Essentially Surrealist graphic and painting technique based on the abandonment of control over the movement of the brush or pen in order to gain contact with the unconscious.

avant-garde Description of an artist or art group "ahead of its time" and striving for new forms of expression.

B

Baader, Johannes (1875–1955) German Dadaist. → p. 116.

Baargeld, Johannes Theodor (1891–1927) German Dada artist.

Bacon, Francis (1909–92) English painter associated with New Figuration. → p. 134.

Bakst, Léon (Lev) (1886–1925) Russian painter, graphic artist, and theater designer. → p. 50.

Balla, Giacomo (1871–1958) Italian Futurist painter. → p. 54.

Balthus (Count Balthasar Klossowski de Rola) (b. 1908) French figurative painter known for his erotic and ambiguous subjects. → p. 122.

Barry, Robert (b. 1936) American painter and Conceptual artist.

Baselitz, Georg (b. 1938) German painter associated with New Figuration. → p. 134.

Basquiat, Jean Michel (1960–88) American Graffiti artist. → p. 132.

Bauhaus Art school for painting, design, architecture, founded 1919 in Weimar, which developed modern industrial forms. → p. 76.

Baumeister, Willi (1889–1955) German Abstract Expressionist and Tachist painter who belonged to the Novembergruppe and Abstraction-Création. → pp. 82, 94–5.

Baziotes, William (1912–63) American Surrealist and Abstract Expressionist painter.

Beardsley, Aubrey (Vincent) (1872–98) Art Nouveau graphic artist.

Beckmann, Max (1884–1950) German Expressionist and New Objectivity painter. → p. 74.

Bell, Larry (b. 1939) American Minimalist sculptor using plexiglass. → p. 128.

CONCEPTS AND NAMES

Bellmer, Hans (1902–75) German Surrealist graphic artist and doll-maker. → p. 106.

Benois, Alexandre (1870–1960) Russian designer and Symbolist painter. → p. 50.

Benton, Thomas Hart (1899–1975) American Regionalist painter. → p. 84.

Bernard, Émile (1868–1941) French Neo-Impressionist and Symbolist painter. → p. 36.

Beuys, Joseph (1921–86) German Conceptual and Performance artist and sculptor. → pp. 116, 126.

Biddle, George (1885–1973) American Scene painter of urban subjects. → p. 84.

Biennale (Bienal, Biennial) Large-scale art exhibitions or fairs held every two years, the most significant being Venice, São Paulo, and the Whitney Museum (New York).

Bill, Max (1908–94) Swiss architect, designer, and geometric painter associated with Abstraction-Création, Op art, and Concrete art. → p. 82.

Birolli, Renato (1906–59) Italian Informel painter; founder of Corrente. → p. 91.

Bishop, Isabel (1902–88) American painter associated with American Scene Painting.

Bissière, Roger (1886–1964) French Abstract Expressionist sculptor and painter. → p. 94.

Blake, Peter (b. 1932) English Pop art sculptor, painter, and designer. → p. 114.

Blaue Reiter *see* **Blue Rider.**

Blossfeldt, Karl (1865–1932) German photographer, especially of close-ups of the natural world. → p. 64.

Blue Rider, The [Der Blaue Reiter] Artists' association founded in 1911 in Munich . → p. 56.

Blue Rose [Golubaia Roza] Russian modernist art group founded in 1907. → p. 15.

Boccioni, Umberto (1882–1916) Italian Futurist sculptor and painter. → p. 54.

Body art, Bodyworks, Body sculpture From the 1960s onwards, a type of Performance art or other art form that employs as its expressive material the human body, often that of the artist. → p. 116.

Bolotowsky, Ilya (1907–81) Russian-born American geometric abstract painter. → p. 108.

Bomberg, David (1890–1957) English Vorticist, then Expressionist painter.

Bonnard, Pierre (1867–1947) French Nabis and Intimiste painter. → p. 38.

Bourgeois, Louise (b. 1911) Franco-American installation artist. → p. 151.

Bragaglia, Anton Giulio (1890–1960) Italian Futurist Photodynamist photographer. → p. 64.

Bragaglia, Arturo (1893–1962) Italian Futurist Photodynamist photographer. → p. 64.

Brancusi, Constantin (1876–1957) Romanian-born abstract and figurative sculptor. → p. 64.

Brandt, Bill (1904–83) British landscape photographer. → p. 64.

Braque, Georges (1882–1963) French Cubist painter. → p. 46.

Brassaï (Gyula Halász) (1899–1984) Hungarian-born photographer of Paris. → p. 64.

Brauer, Arik (Erich) (b. 1929) Austrian Fantastic Realist painter. → p. 106.

Breker, Arno (1900–91) German sculptor and architect under Nazism. → p. 86.

6

Breton, André (1896–1966) French leader of Surrealism. → p. 80.

Brisley, Stuart (b. 1933) British Body artist. → p. 116.

Brodsky, Isaak I. (1883–1939) Soviet Socialist Realist painter. → p. 86.

Broodthaers, Marcel (1924–76) Belgian Conceptual artist. → p. 126.

Brücke, Die Artists' association founded in Dresden in 1905, marking the onset of German Expressionism. → p. 42.

Brus, Günter (b. 1938) Austrian artist belonging to the Vienna Actionists. → p. 117.

Burchfield, Charles (1893–1967) American painter associated with American Scene Painting. → p. 84.

Burden, Chris (b. 1946) American Body and Conceptual artist. → p. 116.

Buren, Daniel (b. 1938) French Conceptual artist. → p. 126.

Burgin, Victor (b. 1941) English Conceptual artist. → p. 126.

Burliuk, David (1882–1967) Russian avant-garde painter and critic. → p. 128.

Burne-Jones, Sir Edward (1833–98) English Pre-Raphaelite painter. → p. 36.

Burri, Alberto (1915–95) Italian Abstract Expressionist painter and sculptor. → p. 102.

Butler, Reg (1913–81) British semi-figurative sculptor in metal.

C

Calder, Alexander (1898–1976) American Abstract Expressionist sculptor and painter. → p. 96.

Cameron, Julia (1815–79) British photographer. → p. 64.

Campigli, Massimo (born Max Ihlenfeld) (1895–1971) Italian painter and printmaker associated with Novecento Italiano. → p. 86.

Caro, Sir Anthony (b. 1924) British abstract and Minimalist sculptor. → p. 128.

Carrà, Carlo (1881–1966) Italian Pittura Metafisica and Futurist painter; later associate of Novecento Italiano. → p. 70.

César (César Baldaccini) (b. 1921) French sculptor known for his "compressions" of metal objects (cars, etc.).

Cézanne, Paul (1839–1906) French Impressionist and Neo-Impressionist painter and precursor of the modern movement. → p. 30.

Chadwick, Lynn (b. 1914) English Abstract Expressionist sculptor.

Chagall, Marc (1887–1985) Russo-French Symbolist painter of mystical Jewish subjects. → p. 50.

Chia, Sandro (b. 1946) Italian Arte Cifra painter. → p. 136.

Chicano art Art made by and often concerning the social situation of Americans of Mexican origin (since 1980s). → p. 154.

Chillida, Eduardo (b. 1924) Spanish Abstract Expressionist sculptor. → p. 96.

Chirico, Giorgio de (1888–1978) Italian Pittura Metafisica and Surrealist painter. → pp. 70, 80.

Christo (Christo Javacheff) and **Jeanne-Claude** (both b. 1935) Bulgarian-French sculptors, famous for wrapping landscapes and buildings. → p. 130.

Classicism Art style modeled on Graeco-Roman antiquity and characterized by clear linear forms.

Claudel, Camille (1864–1943) French Impressionist sculptor. → p. 32.

Clemente, Francesco (b. 1952) Italian Arte Cifra painter. → p. 136.

Close, Chuck (b. 1940) American Superrealist portrait painter. → p. 122.

Cobra Expressionist painting movement founded in France in 1948. → p. 102.

Color Field Painting Late Abstract Expressionist tendency based on large expanses of color. → p. 104.

color symbolism An important component of certain types of painting (especially Symbolism), according to which colors possess specific meaning: e.g. red=love; blue=loyalty; black=sadness; white=joy; green=hope; yellow=danger.

combine painting Combination of painting, collage, and large three-dimensional objects in a single work. → p. 110.

complementary colors Each color has its "contrary" that lies on the opposite side of the color wheel: green/red, yellow/blue, orange/violet.

composition The layout and order of elements in a picture.

Conceptual art Art form prevalent from 1965 in which the idea behind the piece has precedence over craft and execution. → p. 126.

Concrete art European art tendency in the 1920s in which all figurative allusions are rejected in favor of geometric precision employing rectangles, squares, triangles, and circles (as in Max Bill and van Doesburg). Similar elements are to be found in Constructivism.

Constant (Constant Anton Nieuwenhuys) (b. 1920) Dutch painter; member of Cobra. → p. 102.

Constructivism Approach to art and architecture that began in 1915 in Russia, based on geometrical forms in carefully calculated arrangements. → pp. 60–63.

contour Outline of an object in a painting. Through the careful use of contour, a greater illusion of three-dimensionality can be attained.

contrast Term for tonal juxtaposition in the picture such as that between light and dark or warm and cold tones, etc., as well as between any color and its complementary: green/red, yellow/blue, orange/violet.

copy A duplicate of an art object made by the artist's own or another hand.

Corinth, Lovis (1858–1925) German Impressionist painter; member of the Berlin Secession. → p. 30.

Corneille (b. 1922) Dutch Abstract Expressionist painter; member of the Cobra group. → p. 102.

Cornell, Joseph (1903–72) American semi-Surrealist assemblage sculptor.

Corrente Italian anti-Fascist movement founded in 1938. → p. 88.

Cottingham, Robert (b. 1935) American Superrealist painter. → p. 122.

Cross, Henri-Edmond (1856–1910) French Neo-Impressionist painter. → p. 34.

Cubism Early avant-garde style originating in Paris in 1907 that employed geometric and three-dimensional basic structures to represent objects, often from more than one point of view. There were two phases to the style: Analytical Cubism (c. 1909–11), in which the objects depicted were divided into their component parts and rearranged; and Synthetic

Cubism (c. 1912–14), where the objects were built up from component or pre-existing elements (e.g. collage). → pp. 46–9.

Cubo-Futurism Russian movement from the 1910s which combined Cubism, Futurism, and folklore imagery.

Cucchi, Enzo (b. 1949) Italian Art Cifra painter, graphic artist, and sculptor. → p. 136.

Curry, John Steuart (1897–1946) American Regionalist painter who produced scenes of his native rural Kansas. → p. 84.

D

Dada, Dadaism Founded in 1916, the Dada group rejected all traditional notions of art. → p. 66.

Dalí, Salvador (1904–89) Spanish Surrealist painter and sculptor. → p. 80.

Davies, John (b. 1946) British Superrealist sculptor. → p. 124.

Davis, Ron (b. 1937) American shaped-canvas painter. → p. 108.

Davis, Stuart (1894–1964) American Cubist and abstract painter.

décollage Technique by which an artwork is created by the tearing or cutting of a pre-existing poster, etc.

Degas, Edgar (1834–1917) French Impressionist painter, draftsman, and printmaker. → pp. 30, 32.

Deineka, Alexander A. (1899–1969) Soviet Socialist Realist painter. → p. 86.

de Kooning, Willem (1904–97) Dutch-born American Abstract Expressionist painter. → p. 92.

Delaunay, Robert (1885–1941) French Orphic painter and member of Abstraction-Création. → p. 58.

Delaunay(-Terk) Sonia (1885–1979) Russo-French Orphic painter and member of Abstraction-Création. → p. 58.

Delvaux, Paul (1897–1994) Belgian figurative Surrealist painter.

Demachy, Robert (1859–1936) Leading Pictorialist photographer before the First World War. → p. 64.

Demuth, Charles (1883–1935) American Precisionist painter.

Denis, Maurice (1870–1943) French painter and co-founder of the Nabis. → p. 38.

Derain, André (1880–1954) French Fauvist painter. → p. 44.

De Stijl *see* Stijl, De.

Dibbets, Jan (b. 1941) Dutch Conceptual artist and photographer. → p. 130.

Die Brücke *see* **Brücke, Die.**

Dine, Jim (b. 1935) American Pop art painter and Performance artist. → pp. 112, 114.

Divisionism *see* **Pointillism.**

Dix, Otto (1891–1969) German often satirical painter of the New Objectivity school and the Novembergruppe. → pp. 72, 88.

Doesburg, Theo van (1883–1931) Dutch architect and painter; member of Abstraction-Création and co-founder of De Stijl. → p. 68.

Dongen, Kees van (1877–1968) Dutch-French Fauvist painter, mainly of figures. → p. 44.

Donkey's Tail Exhibition in 1912 of folklore-inspired modernist art in Moscow. → p. 50.

Dove, Arthur (1880–1946) American painter and pioneer of abstract art.

drip painting Technique whereby the brush is abandoned and the paint is dripped directly, e.g. from the can, onto a canvas laid out on the floor; a method used particularly by Pollock. → p. 92.

Dubuffet, Jean (1901–85) French Art Brut painter and theoretician; also collagist and Performance artist. → p. 98.

Duchamp, Marcel (1887–1968) French Dadaist and Conceptual artist and sculptor. → p. 66.

Duchamp-Villon, Raymond (1876–1918) French Cubist sculptor. → p. 48.

Dufy, Raoul (1877–1953) French Fauvist painter. → p. 44.

E

Earth art *see* **Land art.**

easel painting A painting executed on an easily transportable support such as a wooden panel, canvas, or cardboard at the easel. (As opposed to a mural or fresco, etc., which cannot in general be removed).

Eddy, Don (b. 1944) American Superrealist painter. → p. 122.

encaustic Ancient painting technique still in use, in which hot wax color is applied over the ground.

engraving (line engraving) Print taken from a plate e.g. of copper, incised by a burin (instrument) with lines, the ink remaining in the incisions and run through a printer onto the paper.

Ensor, James (1860–1949) Belgian Symbolist/Expressionist painter and herald of Surrealism. → p. 36.

entartete Kunst [degenerate art] Qualified artists who did not conform to the diktats of National Socialism in Germany and were placed on a list of proscribed artists, who were forbidden to paint, and whose works were removed from museums. The *entartete Kunst* shows were staged by the Nazis in 1937 to ridicule the kind of art they despised. → p. 88.

Epstein, Sir Jacob (1880–1959) American-born English Vorticist sculptor. → p. 54.

Ernst, Max (1891–1976) German-born American, then French, Dadaist and Surrealist painter and sculptor. → pp. 66, 80.

Estes, Richard (b. 1936) American Superrealist painter. → p. 122.

etching Print taken from a plate e.g. of copper, incised and dipped in acid to bring out the line, the ink remaining in the incisions and pulled through a printer onto the paper.

Euston Road School Late 1930s British naturalistic urban painting movement.

Expressionism Early 20thC art tendency in which the expression of the artist's emotional approach to the subject using uncomplicated techniques is paramount. → p. 42.

Exter, Alexandra (1882–1949) Russian avant-garde painter and designer. → p. 50.

F

Falk, Robert (1886–1958) Russian painter. → p. 50.

Fantastic Realism Late 1950s tendency in painting close to Surrealism, which treated strange, other-worldly themes. → p. 106.

Fautrier, Jean (1898–1964) French painter; precursor of Informel. → pp. 94, 102.

Fauvism Figurative art style that appeared in France in 1905 using bright, unmixed colors. → p. 44.

Feeley, Paul (1910–66) American shaped-canvas painter. → p. 108.

Feininger, Lyonel (1871–1956) American-German Expressionist, then Bauhaus painter and graphic artist. → p. 76.

Feminist art Art which deals explicitly with women's issues in a polemical manner.

Fetting, Rainer (b. 1949) German Neue Wilde painter associated with New Figuration. → p. 138.

figurative painting/sculpture Representational painting or sculpture.

Filonov, Pavel (1883–1941) Russian figurative painter. → p. 50.

Finch, Willy (Alfred William) (1854–1930) Belgian Neo-Impressionist painter. → p. 34.

Fini, Léonor (1908–96) French Fantastic Realist painter. → p. 106.

Finlay, Ian Hamilton (b. 1925) Scottish sculptor, graphic artist, and author.

Fischl, Eric (b. 1948) American painter associated with New Image Painting. → p. 138.

Flavin, Dan (1933–96) American light sculptor and experimental artist. → p. 128.

Fluxus International association of artists formed in Europe in 1962 which spread to America, combining Happenings with Performance art; the artists integrated painting, sculpture, theater, music, and dance, and incorporated audience response. → p. 118.

Fogel, Seymour (b. 1911) American Scene painter of urban subjects. → p. 84.

Fontana, Lucio (1899–1968) Italian sculptor and painter; creator of Spatialism (*Spazialismo*) who associated with Abstraction-Création. → p. 108.

found object *see* **objet trouvé.**

Francis, Sam (1923–94) American Abstract Expressionist painter and graphic artist.

Frankenthaler, Helen (b. 1928) American Abstract Expressionist painter, sculptor, and graphic artist.

Frédéric, Léon (1856–1940) Belgian Symbolist painter. → p. 36.

fresco Method of painting in which powdered pigment is mixed in water and applied still wet to a ground; often used in mural painting.

Freud, Lucian (b. 1922) German-English painter associated with New Figuration. → p. 134.

Frink, Dame Elisabeth (1930–93) British figurative sculptor.

frottage Mostly graphic technique in which a piece of paper or canvas is placed over a stone or a length of wall or flooring and rubbed, e.g. with a pencil, to leave an imprint from which a subject may be derived. → p. 80.

Fuchs, Ernst (b. 1930) Austrian Fantastic Realist painter of the "Wiener Schule." → p. 106.

Futurism Art style founded in 1910 in Italy whose themes included speed, machines, and power. → p. 54.

G

Gabo (Pevsner) Naum (1890–1977) Russo-American Constructivist sculptor and member of Abstraction-Création. → pp. 60, 62.

Gaudier-Brzeska, Henri (1891–1915) French Vorticist sculptor active in England.

Gauguin, Paul (1848–1903) French Post-Impressionist and Symbolist painter; precursor of the modern movement. → p. 36.

genre painting Pictures which take as their subject contemporary everyday life.

Gerasimov, Alexander (1881–1963) Russian Soviet Socialist Realist painter. → p. 86.

gestural painting Style in which the paint is projected onto the support broadly, rapidly, and energetically, so as to leave a trace of the artist's act of painting, as in Abstract Expressionism. → p. 108.

Giacometti, Alberto (1901–66)

Swiss Surrealist and Expressionist sculptor. → p. 96.

Gilliam, Sam (b. 1933) American painter of "suspended paintings." → p. 108.

Glackens, William (1870–1938) American Ashcan and landscape painter.

glaze Thin translucent layer that is applied to an earlier coat of paint, which nonetheless remains visible beneath. The overall effect of glazing depends on the degree to which the solution is diluted.

Gogh, Vincent van (1853–90) Dutch Impressionist and Post-Impressionist painter and fore-runner of Expressionism. → pp. 30, 44.

Goings, Ralph (b. 1928) American Superrealist painter. → p. 122.

Golden Fleece Russian art journal that organized modernist exhibitions in Moscow. → p. 50.

Golub, Leon (b. 1922) American figurative painter associated with New Image Painting. → p. 138.

Goncharova, Natalia (1881–1962) Russian folklore-inspired Futurist. → p. 50.

González-Torres, Felix (1957–1996) Cuban-born artist who specialized in disposable and interactive art.

Gorky, Arshile (1904–48) Armenian-American painter and pioneer of Abstract Expressionism. → p. 92.

Gottlieb, Adolph (1903–74) American Abstract Expressionist painter.

Götz, Karl Otto (b. 1914) German Abstract Expressionist and Tachist painter. → p. 94.

gouache Painting technique using opaque watercolor. The color is bound with glue and lighter tones obtained by the admixture of white pigment. The colors become lighter in tone when dry and look "chalky."

graffiti art Painting inscribed on walls (e.g. with a spraycan) that in 1980s America was incorporated into the art world. → p. 132.

grattage Graphic technique in which the color is scratched from a support with a sharp instrument (e.g. stylus).

Gris, Juan (1887–1927) Spanish Cubist painter, set designer, illustrator, and sculptor. → p. 46.

Gropius, Walter (1883–1969) German-born functionalist architect and Bauhaus pedagogue. → p. 76.

Grosvenor, Robert (b. 1937) American Minimalist sculptor known for textured blocks. → p. 128.

Grosz, George (1893–1959) German-American Dada artist and New Objectivity painter; member of the Novembergruppe. → p. 72.

ground First layer of primer applied on the support (canvas, panel, cardboard, etc.) prior to the visible pigment. Various types may be employed depending on the technique chosen. Also, the background against which especially geometric or abstract motifs or figures appear.

Guayasamín, Oswaldo (1919–99) Ecuadorian muralist. → p. 78.

Guston, Philip (1913–80) American artist influential in New Figuration. → p. 134.

Guttoso, Renato (1912–87) Italian painter and anti-Fascist member of Corrente. → p. 88.

H

Hamilton, Richard (b. 1922) English Pop art painter, graphic artist, designer, and sculptor. → p. 114.

Hanson, Duane (1925–96) Amer-

ican Superrealist sculptor.
→ p. 124.

Happening Performance art that began in the late 1950s in which audience participation is paramount. → p. 112.

Hard-Edge Painting Approach to painting that emerged in the 1960s, especially in America, in which abstract motifs have clean, crisp edges. → p. 108.

Haring, Keith (1958–90) American graphic artist, printmaker, and sculptor; a leading figure in Graffiti art. → p. 132.

Harlem Renaissance The emergence of art (and literature) among the blacks of New York's Harlem quarter in the 1920s, dealing with social subjects and African imagery.

Hartley, Marsden (1877–1943) Pioneer of American abstract painting. → p. 52.

Hartung, Hans (1904–89) German-French Abstract Expressionist and Informel painter. → p. 88.

Hassam, Childe (1859–1935) American Impressionist painter. → p. 30.

Hausmann, Raoul (1886–1971) Austrian Dada and later Surrealist graphic artist, photographer, photomontagist, and painter. → p. 64.

Hausner, Rudolf (1914–95) Austrian Fantastic Realist painter of the "Wiener Schule." → p. 106.

Heartfield, John (1891–1968) German satirical photomontagist. → p. 64.

Heckel, Erich (1883–1970) German Expressionist painter belonging to Die Brücke. → p. 42.

Heizer, Michael (b. 1944) American Land artist. → p. 130.

Held, Al (b. 1928) American Hard-Edge and shaped-canvas painter. → p. 108.

Henri, Robert (1865–1929) American realist painter and teacher.

Hepworth, Dame Barbara (1903–75) British abstract sculptor whose work is centered on nature; associated with Abstraction-Création.

Hesse, Eva (1936–70) German-born American sculptor known for soft and suspended sculpture.

Hine, Lewis Wickes (1874–1940) American realist photographer. → p. 64.

Hinman, Charles (b. 1932) American shaped-canvas painter. → p. 108.

Höch, Hannah (1889–1978) German satirical and Dada photomontagist. → p. 64.

Hockney, David (b. 1937) English-born painter, draftsman, photographer, set designer, and Pop artist working out of Los Angeles. → p. 114.

Hodgkin, Sir Howard (b. 1932) British semi-figurative colorist painter.

Hodler, Ferdinand (1853–1918) Swiss figurative Jugendstil and Symbolist painter.

Hofer, Karl (1878–1955) German painter and member of the Berliner Secession, who followed a path between Expressionism and New Objectivity. → p. 74.

Holzer, Jenny (b. 1950) American installation and Conceptual artist. → p. 126.

Hopper, Edward (1882–1967) American figurative painter of urban scenes. → p. 84.

Horn, Rebecca (b. 1944) German installation and Performance artist. → p. 150.

Hoyland, John (b. 1934) English abstractionist close to Color Field Painting.

Huebler, Douglas (b. 1924)

American Conceptual and Land artist. → p. 130.

Hundertwasser, Friedensreich (1928–2000) Austrian Fantastic Realist graphic artist and painter. → p. 106.

Hyperrealism *see* **Superrealism**.

I

Immendorff, Jörg (b. 1945) German sculptor, printmaker, and painter associated with New Figuration. → p. 134.

impasto Technique or quality where the layers of paint are so thickly applied that the paint acquires a relief structure of its own.

Impressionism Developed in 1874 in France, an approach to painting that stresses fleeting visual effects. The painters attempted to capture the moment, representing light, shade, atmosphere, and movement through everyday subject matter. → pp. 30–33.

Indiana, Robert (b. 1928) American Pop art painter and graphic artist.

Informel *see* **Art Informel**.

installation Describes an artwork in which the artist(s) arrange(s) an entire room or gallery, which can include walls, floor, and ceiling, etc., placing within it art objects among which the viewer is intended to walk. → p. 150.

internet art (Online art) Art made for and distributed through the world wide web (www) on the Internet. → p. 152.

Intimisme (Post-)Impressionist offshoot in which the subjects are domestic scenes conveying a mood of "intimacy"; practitioners from the 1890s include the Nabis painters Vuillard and Bonnard.

Itten, Johannes (1888–1967) Swiss geometric-abstract painter

and teacher at the Bauhaus. → pp 72, 76.

J

Jack (or **Knave**) **of Diamonds** Russian avant-garde association of artists founded in 1910. → p. 50.

Jawlensky, Alexei von (1864–1941) German-Russian Blue Rider and Expressionist painter. → p. 50.

Johns, Jasper (b. 1930) American painter and precursor of Pop art and shaped canvas. → p. 108.

Jones, Allen (b. 1937) English Pop and graphic artist, sculptor, and maker of combine paintings. → p. 114.

Jorn, Asger (1914–73) Danish Abstract Expressionist painter and member of Cobra. → p. 102.

Journiac, Michel (b. 1943) French Body and Performance artist. → p. 116.

Judd, Donald (1928–94) American Minimalist sculptor. → p. 128.

Jugendstil *see* **Art Nouveau**.

K

Kahlo, Frida (1907–54) Mexican painter and wife of Rivera.

Kandinsky, Wassily (1866–1944) Russian Abstract Expressionist painter active mainly in Germany; member of the Blue Rider, teacher at the Bauhaus, and founder of abstract painting. → p. 52.

Kaprow, Allan (b. 1927) American Happening and Performance artist. → p. 112.

Kelley, Mike (b. 1954) American Performance and installation artist also associated with "Slacker" art. → p. 138.

Kelly, Ellsworth (b. 1923) American painter associated with Hard-Edge Painting and shaped canvas. → p. 108.

Kertész, André (1894–1985)

Hungarian photographer.
→ p. 64.

Khnopff, Fernand (1858–1921)
Belgian Symbolist painter and
sculptor.

Kiefer, Anselm (b. 1945) German
painter associated with New Figu-
ration. → p. 134.

Kienholz, Edward (1927–94)
American Concept and environ-
ment artist and sculptor. → p. 114.

Kilimnik, Karen (b. 1955) Ameri-
can installation artist associated
with "Slacker" art.

Kinetic art Art form in which
movement, light, and color com-
bine.

Kippenberger, Martin (1953–97)
German Neo-Expressionist painter.
→ p. 138.

Kirchner, Ernst Ludwig
(1880–1938) German Expression-
ist painter; member of Die Brücke.
→ p. 42.

Kirkeby, Per (b. 1938) Danish
Abstract Expressionist sculptor,
painter, and film-maker active in
Germany.

Kitaj, Ron B. (b. 1932) American
painter, graphic artist, and print-
maker associated with New
Figuration; active in England.
→ p. 134.

Kitchen Sink School British
Social Realist art movement of the
1950s.

kitsch Term covering an ostensi-
bly artistic work which does not
attain an acceptable standard of
artistic creativity.

Klee, Paul (1879–1940) German
painter and printmaker; member
of the Blue Rider and active at the
Bauhaus. → p. 89.

Klein, Yves (1928–62) French
monochrome painter and experi-
mental and Body artist.
→ pp. 110, 116.

Klimt, Gustav (1862–1918) Aus-
trian painter and draftsman; pre-
cursor of and active figure in Vien-
na Jugendstil. → p. 41.

Kline, Franz (1910–62) American
Abstract Expressionist painter.
→ p. 92.

Kobuta, Shigeko (b. 1937) Japan-
ese installation artist.

Kokoschka, Oskar (1886–1980)
Austrian Expressionist painter and
graphic artist. → p. 88.

Kollwitz, Käthe (1867–1945)
German printmaker and painter.

Komar and Melamid (Vitaly
Komar [b. 1943] and Alexander
Melamid [b. 1945]) Russian expo-
nents of the unofficial Sots Art
movement in the USSR and post-
Soviet Russia. → p. 88.

Koons, Jeff (b. 1955) American
avant-garde artist known for his
exploitation of kitsch.

Kosuth, Joseph (b. 1945) Leading
figure in American Conceptual art.
→ p. 126.

Kounellis, Jan (b. 1936) Greek
artist associated with Arte Povera.

Kriz, Vilem (1921–1994) Czech-
born American photographer.

Kruger, Barbara (b. 1945) Ameri-
can Conceptual and photographic
artist. → p. 126.

Kubin, Alfred (1877–1959) Aus-
trian Fantastic Realist draftsman
and printmaker.

Kupka, František (1871–1957)
Czech Orphic painter and graphic
artist associated with Abstraction-
Création; pioneer of abstraction.
→ p. 58.

Kuznetsov, Pavel (1878–1968)
Russian Blue Rose painter.
→ p. 50.

L

Lafontaine, Marie-Jo (b. 1950)
Belgian video and installation
artist.

Lamsweerde, Inez van (b. 1964)

Dutch photographic artist.
→ p. 147.

Land art, Earth art Art trend
from the late 1960s that employs
the land or nature itself as a basis
or medium in its works. → p. 130.

landscape painting Painting
depicting the countryside, sea
(seascape), or towns (city-, town-
scape).

Larionov, Mikhail (1881–1964)
Russian Futurist. → p. 50.

L'art pour l'art Art considered
and produced free from any non-
artistic purposes.

Lassnig, Maria (b. 1919) Austrian
painter associated with New Figu-
ration. → p. 134.

Laurens, Henri (1885–1954)
French Cubist sculptor. → p. 48.

Leal, Fernando (1896–1964)
Mexican muralist. → p. 78.

Le Corbusier (Charles-Edouard
Jeanneret) (1887–1965) Swiss-
French painter, sculptor, and
major modernist architect.
→ p. 82.

Léger, Fernand (1881–1955)
French Cubist painter, ceramist,
designer, and graphic artist; mem-
ber of Abstraction-Création.
→ pp. 46, 82.

Lentulov, Aristarkh (1882–1943)
Russian Cubo-Futurist and abstrac-
tionist. → p. 50.

Lesage, Augustin (1876–1954)
French painter. → p. 98.

Levine, Jack (b. 1915) American
Scene painter of urban subjects.
→ p. 84.

Lewis, Wyndham (1882–1957)
English Vorticist painter. → p. 54.

LeWitt, Sol (b. 1928) American
Miminalist painter and Conceptual
artist. → p. 128.

Liberman, Alexander (b. 1912)
American abstract, Hard-Edge, and
shaped-canvas painter. → p. 108.

Lichtenstein, Roy (1923–97)

American sculptor, printmaker, and
painter; major figure in Pop art.
→ p. 114.

Liebermann, Max (1847–1935)
German Impressionist painter.
→ p. 30.

Lindner, Richard (1901–78)
German-born American painter of
bizarre subjects and predecessor of
Pop art.

Lipchitz, Jacques (1891–1973)
French-American Cubist sculptor.
→ p. 48.

Lissitzky, El (Lazar) (1890–1941)
Russian Constructivist painter,
designer, and photographer; associ-
ated with Abstraction-Création.
→ p. 60.

local color Specific color of an
object as it appears in diffused day-
light against a white background,
and thus independently of colored
light and shade.

Lohse, Richard (1902–88) Swiss
painter representative of Concrete
art.

Long, Richard (b. 1945) English
Land and installation artist and
photographer. → p. 130.

Longo, Robert (b. 1953) American
painter, printmaker, sculptor, instal-
lation, and mixed-media artist; also
associated with New Image Paint-
ing. → p. 138.

Louis, Morris (Morris Louis Bern-
stein) (1912–62) American Color
Field painter.

Luchism *see* **Rayonism.**

Luks, George (1867–1933) Amer-
ican Ashcan painter.

Lüpertz, Markus (b. 1941)
German painter and sculptor
associated with New Figuration.
→ p. 134.

Lüthi, Urs (b. 1947) Swiss trans-
vestite Body artist. → p. 116.

M

Macdonald-Wright, Stanton

(1890–1973) American pioneer of abstract art.

Mack, Heinz (b. 1931) German Kinetic artist and co-founder of the Zero group. → p. 120.

Macke, August (1887–1914) German Blue Rider painter and draftsman. → p. 56.

Magnelli, Alberto (1888–1971) Italian abstract painter. → p. 91.

Magritte, René (1898–1967) Belgian figurative Surrealist painter. → p. 80.

Maillol, Aristide (1861–1944) French sculptor, especially of female nudes.

Malczewski, Jacek (1854–1926) Polish Symbolist painter. → p. 36.

Malevich, Kasimir (1878–1935) Russian painter; pioneer of abstraction and originator of Suprematism. → p. 60.

Manessier, Alfred (1911–93) French Abstract Expressionist painter. → p. 94.

Manet, Edouard (1832–83) French painter and pioneer of Impressionism. → p. 30.

Mangold, Robert (b. 1937) American Minimalist painter. → p. 128.

manifesto A text laying down the tenets of a (new) art school.

Man Ray (Emmanuel Radnitzky) (1890–1976) American Dada and Surrealist photographer, painter, sculptor, and film-maker.
→ pp. 66, 80.

Manzoni, Piero (1933–63) Italian Concept and Body artist. → p. 116.

Marc, Franz (1880–1916) German Blue Rider painter.
→ p. 56.

Marden, Brice (b. 1938) American Minimalist painter. → p. 128.

Maria, Walter de (b. 1935) American Land artist. → p. 130.

Marinetti, Filippo Tommaso (1876–1944) Leading theorist of Italian Futurism. → p. 54.

Marini, Marino (1901–80) Italian figurative sculptor known for horse subjects. → p. 96.

Martin, Agnes (b. 1912) Canadian-born Minimalist and Hard-Edge painter. → pp. 108, 128.

Masson, André (1896–1987) French Surrealist and automatist painter; forerunner of Informel. → p. 80.

Mathieu, Georges (b. 1921) French Tachist and Informel painter. → p. 100.

Matisse, Henri (1869–1954) French Fauvist painter, graphic artist, and sculptor. → p. 44.

Matta (Roberto Matta Echaurren) (b. 1911) Chilean Surrealist painter and graphic artist.

Matter Painting Artistic procedure in which the artist transforms his artwork by physical intervention e.g. cutting, burning, or damaging the paint layer by use of acids. → p. 94.

McLean, Richard (b. 1934) English Superrealist painter. → p. 122.

medium Liquid substance mixed with the pigment to make paint (oil, emulsion, acrylic, resin, etc.).

Meidner, Ludwig (1884–1966) German Expressionist painter.
→ p. 72.

Merkurov, Sergei (1881–1952) Russian monumental sculptor associated with Socialist Realism.
→ p. 86.

Merz, Mario (b. 1925) Italian painter, draftsman, and sculptor; leading figure in Arte Povera.

Metaphysical Painting *see* **Pittura Metafisica.**

Mexican Mural Renaissance 1920s–1930s muralist movement that rejuvenated Mexican art. → p. 78.

Minimalism, Minimal Art Art tendency from the 1960s which

limits the visual and formal impact of the work to a "minimum" through the use of simple, geometric forms. → p. 128.

Miró, Joan (1893–1983) Spanish (Catalan) Surrealist painter and printmaker. → p. 80.

Modigliani, Amedeo (1884–1920) Italian painter, especially of female nudes, based in Paris.

Moholy-Nagy, László (1895–1946) Hungarian Constructivist painter, photographer, filmmaker, and sculptor; associated with Abstraction-Création and the Bauhaus. → pp. 76, 82.

Mondrian, Piet (1872–1944) Dutch Constructivist painter associated with Abstraction-Création and co-founder of De Stijl. → pp. 68, 82.

Monet, Claude (1840–1926) French Impressionist painter and forerunner of modern painting. → p. 30.

monochrome Term covering single-hued surfaces. In painting, either a single overall tone or varying tones of a given color (e.g. light, mid-, or dark blue) on a support.

Moore, Henry (1898–1986) English figurative and abstract sculptor and printmaker. → p. 96.

Morandi, Giorgio (1890–1964) Italian painter, draftsman, and printmaker of still-life subjects.

Moreau, Gustave (1826–98) French Symbolist painter. → p. 36.

Morley, Malcolm (b. 1931) English Superrealist painter. → p. 122.

Morris, Robert (b. 1931) American Minimalist sculptor. → p. 128.

Motherwell, Robert (1915–91) American Abstract Expressionist and Action painter. → p. 92.

motif The central subject chosen by the artist for a work, be it land-

scape, figure, object, pattern, etc. Motif also designates distinctive elements in a painting, sculpture, or building.

Mucha, Alphonse (1860–1939) Czech Art Nouveau painter and poster artist.

Mueck, Ron (b. 1958) British sculptor associated with the Young British Artists. → p. 124.

Muehl, Otto (b. 1925) Vienna Action artist. → p. 117.

Mueller, Otto (1874–1930) German Expressionist painter and member of Die Brücke. → p. 42.

Mukhina, Vera (1889–1953) Soviet Socialist Realist sculptor. → p. 86.

multiple Art form in which—rather than there being a single original piece—a work is issued originally in many editions and thus made accessible to a wide public.

Munch, Edvard (1863–1944) Norwegian painter and pioneer of Expressionism. → p. 36.

mural The oldest form of painting, dating back to cave-painting, appearing often in fresco on walls, and also, more loosely, on the vaults or ceilings of a building. *See also* **Mexican Mural Renaissance**.

Murray, Elizabeth (b. 1940) American painter of multiple shaped canvases. → p. 108.

Muybridge, Eadweard (1830–1904) British photographer. → p. 64.

N

Nabis Post-Impressionist art group founded in Paris in 1889 that encouraged decorative and symbolic elements. → p. 38.

naive art Denotes painting by untutored artists who learned their craft outside the schools and the

tradition. Works often seem childish and awkward-looking.

Namuth, Hans (1915–1990) American photographer of Action painters. → p. 64.

Nash, Paul (1889–1946) English painter and war artist influenced by Surrealism.

National Socialist art Art produced in Germany (1933–45) conforming to the Nazi party line. → p. 86.

naturalism *see* **realism.**

Nauman, Bruce (b. 1941) American Conceptual and video artist. → p. 149.

Nay, Ernst Wilhem (1902–68) German Abstract Expressionist and Tachist painter. → p. 100.

Neo-Expressionism A current in painting and sculpture of the late 1970s and 1980s that reworked Expressionism (especially German) in reaction against the purity of Minimal art. → p. 134.

Neo-Feminist art Art from the 1980s onwards that addresses the issue of feminism since the initial wave of extremist ideological feminism of the 1960s. → p. 154.

Neo-Geo (Neo-Geometric Conceptualism) New York based mid-1980s postmodern art movement centered on appropriation of 1960s styles.

Neo-Impressionism Art movement originating in 1886 in France that renewed Impressionism's interest in light and developed the painting technique of Pointillism. → p. 34.

Neo-Plasticism Mondrian's term for geometrical abstraction.

Neo-primitivism Russian tendency in the 1910s that returned to peasant art for inspiration. → p. 50.

Neue Künstlervereinigung München Influential group of painters founded in 1909 who integrated modern French influences into German art; their number included Kandinksy, Jawlensky, Hofer, and Marc. The group split when Kandinsky and Marc co-founded Die Brücke.

Neue Sachlichkeit *see* **New Objectivity.**

Neue Wilde German Neo-Expressionist figurative painting grouping of the 1980s. → p. 134.

Nevinson, C.R.W. (1889–1946) English war, Vorticist, and Futurist painter. → p. 54.

New American Expressionism *see* **New Image Painting.**

New Figuration Broad term covering the revival of figurative (but not Superrealist) painting in Europe and the United States from the late 1960s. → p. 134.

New Image Painting, New American Expressionism Term covering late 1970s American Neo-Expressionist figurative painting. → p. 138.

Newman, Barnett (1905–70) American Abstract Expressionist painter and exponent of monochrome and Color Field Painting. → p. 104.

New Objectivity [Neue Sachlichkeit] Tendency in 1920s–1930s German painting centered on caustic social realism with an often Fantastical edge. → p. 74.

New Realism Art style prevalent around mid-1950s to mid-1960s in Europe (especially France) and America. The term "realism" here refers to the way a mixture of depicted objects and real everyday materials were mounted directly onto a piece. In France the movement was known as Nouveau Réalisme. → p. 110.

Nicholson, Ben (1894–1982)

English painter and associate of Abstraction-Création. → p. 82.

Nitsch, Hermann (b. 1938) Austrian artist of Vienna Actionism. → p. 117.

Noland, Kenneth (b. 1924) American exponent of Color Field Painting. → p. 108.

Nolde, Emil (1867–1956) German Expressionist painter and member of Die Brücke. → p. 88.

Nouveau Réalisme *see* **New Realism.**

Novecento Italiano Italian 1930s realist and political conservative art association that included Carrà, Marini, Campigli, and Sironi.

Novembergruppe Anti-governmental and satirically minded association of artists founded in Berlin in 1918. → p. 72.

O

objet trouvé [found object] An object found by the artist and included in an artwork; its purpose is to stress the importance of chance in creation and minimize the notion of the artist's craft and "inspiration."

Oelze, Richard (1900–80) German Fantastic Realist painter. → p. 106.

œuvre The complete works of an artist.

oil paint Paint color comprising a pigment suspended in oil (linseed, poppyseed, or walnut) applied with a brush or painter's knife onto a support.

O'Keeffe, Georgia (1887–1986) American painter of natural subjects; close to Precisionism.

Oldenburg, Claes (b. 1929) American Pop art painter and sculptor famous for his Soft sculpture. → p. 112.

Online art *see* **internet art.**

opaque color Coat of paint applied that covers up the layers of color or the ground underneath.

Op art Trend emerging in 1965 that created optical effects and illusions, which were often geometrical. → p. 120.

Oppenheim, Dennis (b. 1938) American Conceptual, Performance, and Land artist.

Oppenheim, Meret (1913–85) German-Swiss artist whose work is close to Surrealism.

Orozco, José Clemente (1883–1949) Mexican painter and muralist. → p. 78.

Orphism France-based post-Cubist art movement that stressed the music-like harmonies between forms and, especially, colors. → p. 58.

Ozenfant, Amedée (1886–1966) French painter and teacher; originator of Purism. → p. 90.

P

Paik, Nam June (b. 1932) Korean Video, Conceptual, and Performance artist. → p. 118.

Paladino, Mimmo (b. 1948) Italian Arte Cifra and Transavantgarde painter and sculptor. → p. 136.

palette Oval (or rectangular) piece of wood or artificial board on which paints are mixed. In a figurative sense the term covers the color scheme selected by the painter for a body of work or his whole œuvre.

Pane, Gina (1939–90) French Body artist. → p. 116.

Paolozzi, Sir Eduardo (b. 1924) English sculptor, graphic artist, film-maker; major impetus behind Pop art in Britain. → p. 114.

pastel painting Method of painting in dry (body) color without a medium using colored chalks. The technique allows for gradual transitions in hatching and scope for

reworking. Because it is easily smudged, the surface has to be fixed with a spray or additional coat. Pastel is an technique that lies between painting and drawing.

"Pathetic" art Primarily installation art made in a "casual" manner, often with allusions to family dysfunction (e.g. soiling, toys) and the schizophrenic (since 1990s). → p. 154.

Pattern and Decoration, P&D, Pattern Painting Mainly American and often female 1980s phenomenon of decorative painting based on visual pleasure and emphasizing folk and craft models.

Pearlstein, Philip (b. 1924) American realist painter and influence on New Figuration. → p. 122.

Pechstein, Max (1881–1955) German Expressionist painter and printmaker; member of Die Brücke and the Novembergruppe. → pp. 42, 72.

Pellizza da Volpedo, Giuseppe (1868–1907) Italian Neo-Impressionist painter. → p. 34.

Penck, A. R. (b. 1935) German painter associated with New Figuration. → p. 134.

Performance art, Action art An art form in which the artist(s) play(s) an often programmed role in public. → pp. 110, 112.

Permeke, Constant (1886–1952) Belgian Expressionist painter.

perspective An artistic means used in drawing or painting by which the presentation of the planes gives the impression of spatial depth.

Peterhans, Walter (1897–1960) German photographer. → p. 64.

Pevsner, Antoine (1884–1962) Russo-French Constructivist painter and sculptor; associate of Abstraction-Création. → pp. 60, 62.

Phillips, Peter (b. 1939) English Pop artist. → p. 114.

Photodynamism Futurist photography that depicted objects in movement by multiple exposures. → p. 64.

photomontage Reassembled photos stuck together in the way of a collage to form a new, unexpected image. → pp. 64, 146.

Photorealism Superrealism produced directly from photographs, often on moveable screens. → p. 122.

Picabia, Francis (1879–1953) French Dada artist and influence on postmodern painting. → p. 66.

Picasso, Pablo (1881–1973) Spanish painter, sculptor, and ceramist; leading figure in Cubism, Expressionism, and in the development of modernism. → p. 46.

Pictorialism 19thC and early 20thC photographic tendency that sought to imitate painting in its compositions and techniques. → p. 64.

Piene, Otto (b. 1928) German Op art painter, graphic artist, and sculptor; co-founder of the Zero group. → p. 120.

Pissarro, Camille (1830–1903) French Impressionist landscape painter. → pp. 30, 34.

Pistoletto, Michelangelo (b. 1933) Italian Pop art painter and installation artist.

Pittman, Lari (b. 1952) American postmodern painter. → p. 143.

Pittura Metafisica [Metaphysical Painting] Painting style formed in Italy in 1917, based on the evocation of mysterious places and enigmatic "metaphysical" objects. → p. 70.

Plastov, Arkady (1893–1972) Soviet Socialist Realist painter. → p. 86.

plein air Impressionist painting

technique whereby the work was not only sketched but actually painted outside in front of the natural subject e.g. landscape, and no longer in the studio.

plinth The support (stone, metal, wood) beneath a sculpture. Sculptures without plinths are characteristic of later 20thC sculpture.

Pluralism General characteristic of various contemporary artistic practices and trends where no one overarching aesthetic or technique predominates. → pp. 140–51.

Pointillism, Divisionism Neo-Impressionist movement, especially in France, that refers specifically to the technique of juxtaposing little dots (in French, *points*) of paint of a single hue. → p. 34.

Poliakoff, Serge (1906–69) Russian-born Abstract Expressionist painter. → p. 94.

Polke, Sigmar (b. 1941) German painter associated with New Figuration. → p. 134.

Pollock, Jackson (1912–56) American painter; central figure in and originator of Abstract Expressionism. → p. 92.

polychromy multi-colored (opposite, "monochrome").

Pop art American-British 1960s movement originating in 1956 that plays wittily on modern "popular" and consumer motifs. → p. 114.

Popkov, Viktor E. (1932–74) Soviet Socialist Realist painter. → p. 86.

Popova, Lyubov (1889–1924) Russian Cubist painter. → p. 50.

Portinari, Cândido (1903–62) Brazilian muralist. → p. 78.

portrait The representation of a head (or head and body: "full-length") or one or more people ("sitters") in full-face, three-quarters, or profile.

Postmodernism Describes art especially of the 1980s, which departs from strict modernism in quoting ("appropriating") elements from classical, baroque, and even modern vocabularies. The term was first used in connection with architecture but has since been extended to the other arts.

Post-Painterly Abstraction American tendency in which various painters reacted against gesturalism in Abstract Expressionist painting to create works of linear clarity.

Precisionism American painting movement c. 1915–20 treating urban, industrial subjects in clean-cut outlines and muted, Cubist tones; Demuth was the main representative.

Pre-Raphaelites, Pre-Raphaelitism Mid-19thC English movement in painting that heralded the religious and mythological themes of Symbolism.

primary colors As regards painting, pigments in the three basic colors of red, yellow, and blue, which cannot be mixed from the other colors.

"primitive art" A tendency in modern painting and sculpture that employs folk art, children's creations, or, especially, the art of ethnic peoples, as its inspiration.

proportion Term from Latin denoting a balance between the relative sizes of elements (e.g. of the human figure) in an artwork.

provenance The previous owners or heirs of an artwork; the list enumerating them.

Purism A 1920s French painting style founded in 1918 by Ozenfant and Le Corbusier, which was a smooth contoured, cooler version of still-life Cubism.

Puvis de Chavannes, Pierre

(1824–98) French painter and forerunner of Symbolism. → p. 36.

Puyo (Emile Joachim) Constant (1857–1933) Pictorialist photographer. → p. 64.

Q, R

Quinones, Lee George (b. 1960) Puerto-Rican Graffiti artist. → p. 132.

Radziwill, Franz (1895–1983) German painter associated with New Objectivity.

Rainer, Arnulf (b. 1929) Austrian painter associated with New Figuration.

Rauschenberg, Robert (b. 1925) American painter associated with New Realism; precursor of Pop art and maker of combine paintings. → pp. 110–11.

Rayonism, Rayism, Luchism Abstract or semi-abstract painting practised in Russia especially by Larionov (1911–14), based on mystic light theories. → p. 50.

ready-made Art form in which an everyday utensil is removed from its functional context and made into an artwork by the act of an artist and displayed, e.g. in a museum.

realism, realists, naturalism Art style in which the objects or figures in the picture are depicted as they appear in (objective) reality. Also a particularly French 19thC movement, Realism or Naturalism.

Redon, Odilon (1840–1916) French Symbolist painter and graphic artist. → p. 36.

Regionalism Refers particularly to an Realist American art movement of the 1930s concerned with the country and its troubles. → p. 84.

Reinhardt, Ad (1913–67) American monochrome painter; forerunner of Minimal and Conceptual art. → p. 120.

relief Denotes a sculptural work in which the formal elements emerge from or are sunken into a planar surface.

Renaissance Art style deriving from antiquity, which began in Italy in the $14^{th}/15^{th}$ century, and spread to western and central Europe. The term is from the Latin for "rebirth".

Renger-Patzsch, Albert (1897–1966) German photographer. → p. 64.

Renoir, Pierre-Auguste (1841–1919) French Impressionist landscape and, primarily, figure painter. → pp. 30–32.

Repin, Ilya (1844–1930) Russian Realist painter. → p. 50.

replica Exact duplicate of an original artwork, either by the artist or by another hand with his permission, and signed by him.

reproduction Copy of an artwork (produced by a hand other than the artist) reproduced many times, either in book, poster, print, or (for sculpture) three-dimensional form.

restoration, restoring The repair of an artwork to forestall or reverse the effects of the passage of time or damage.

Revueltas, Jose (1893–1983) Mexican muralist. → p. 78.

Richier, Germaine (1912–59) French Abstract Expressionist sculptor and graphic artist. → p. 96.

Richter, Gerhard (b. 1932) German postmodern Superrealist and abstract painter. → p. 122.

Richter, Hans (1888–1976) German-born Dada artist and filmmaker.

Rietveld, Gerrit (1888–1964) Dutch architect and furniture designer; collaborator with De Stijl. → p. 68.

Riley, Bridget (b. 1931) English Op art painter. → p. 120.

Rivera, Diego (1886–1957) Mexican painter and muralist. → p. 78.

Rivers, Larry (b. 1923) American Abstract Expressionist painter, sculptor, and graphic artist.

Rodchenko, Alexander (1891–1956) Russian Constructivist painter, designer, and photographer. → pp. 60, 62.

Rodin, Auguste (1840–1917) French Impressionist sculptor. → p. 32.

Rolhfs, Christian (1849–1938) German Expressionist painter. → p. 88.

Romanticism 19thC art movement that reacted against the strictness and formalism of classicism, and which is characterized by a strong emotional charge.

Rosenquist, James (b. 1933) American Pop art painter, sculptor, and graphic artist. → p. 114.

Rosso, Medardo (1858–1928) Italian Impressionist sculptor in wax and bronze. → p. 32.

Rothko, Mark (1903–70) American Color Field painter. → p. 104.

Rousseau, Henri (Le Douanier Rousseau) (1844–1910) French Naive painter. → p. 98.

Roussel, Ker-Xavier (1867–1944) French painter and member of the Nabis. → p. 38.

Rozanova, Olga (1886–1918) Russian Suprematist painter and Futurist book designer. → pp. 50, 128.

Ruscha, Ed (b. 1937) American shaped-canvas painter and photographic book artist. → p. 108.

Russolo, Luigi (1885–1947) Italian Futurist painter and composer. → p. 54.

Ryder, Albert Pinkham (1847–1917) American Symbolist painter. → p. 36.

Ryman, Robert (b. 1930) American painter of white monochromes and shaped-canvas work. → p. 128.

Rysselberghe, Théo van (1862–1926) Belgian Neo-Impressionist painter. → p. 34.

S

Sacred art Art devoted to religious or spiritual subjects.

Saint Phalle, Niki de (b. 1930) French sculptor, especially of misshapen female subjects.

Salle, David (b. 1952) American Neo-Expressionist painter and graphic artist associated with New Image Painting. → p. 138.

Salt, John (b. 1937) British-American Superrealist painter and graphic artist. → p. 122.

Sander, August (1876–1964) German post-Pictorialist photographer specializing in social scenes. → p. 64.

Saura, Antonio (b. 1930) Spanish Abstract Expressionist painter and graphic artist. → p. 94.

"Scatter" art Primarily installation art arranged in a deliberately disorganized way out of discarded materials (since 1980s). → p. 154.

Schad, Christian (1894–1982) German painter and avant-garde photographer associated with New Objectivity. → p. 74.

Schiele, Egon (1890–1918) Austrian Jugendstil painter and graphic artist.

Schlemmer, Oskar (1888–1943) German painter and sculptor; teacher at the Bauhaus. → p. 76.

Schmidt-Rottluff, Karl (1884–1976) German Expressionist painter; member of Die Brücke and the Novembergruppe. → pp. 42, 72.

Schnabel, Julian (b. 1951) American painter associated with New Image Painting. → p. 138.

Schrimpf, Georg (1889–1938)

German painter associated with New Objectivity. → p. 74.

Schröder-Sonnenstern, Friedrich (1892–1982) Lithuanian-born Fantastic Realist artist. → p. 106.

Schumacher, Emil (1912–99) German Abstract Expressionist and Tachist painter. → p. 94.

Schwarzkogler, Rudolf (1940–69) Austrian Vienna Actionist. → p. 117.

Schwitters, Kurt (1887–1948) German painter, mixed-media sculptor, typographer, and designer; leading figure in Dada, and member of Abstraction-Création and the Novembergruppe. → pp. 66, 72, 82.

screenprint Print made through a silk (hence "silkscreen print") or other textile mesh screen over a piece of paper, the ink being laid on with a rubber blade (squeegee); the motifs are outlined using a stencil; widespread since the 1960s.

Secession, Sezession An artistic splinter group that leaves a larger association. The term was prevalent in German-speaking lands (e.g. Munich, 1892; Vienna, 1897; Berlin, 1899).

Segal, George (1924–2000) American sculptor specializing in Superrealist plaster casts, including nudes.

Segantini, Giovanni (1858–99) Italian Symbolist painter. → p. 36.

Serial art Art form in which an unvarying single motif is placed sequentially in an artwork. It concerns a series of the same motif in one painting.

Serov, Valentin (1865–1911) Russian realist painter. → p. 50.

Sérusier, Paul (1864–1927) French Nabis painter and art theorist. → p. 38.

Seurat, Georges (1859–91)

French Neo-Impressionist painter and creator of Pointillism. → p. 34.

Severini, Gino (1883–1966) Italian Futurist and Cubist painter. → p. 54.

Shahn, Ben (1898–1969) American Scene painter of urban subjects. → p. 84.

shaped canvas Primarily abstract, often Hard-Edge, paintings produced on canvases of other than rectangular shape in the early 1960s. → p. 108.

Shinn, Everett (1876–1953) American Ashcan painter and printmaker.

Signac, Paul (1863–1935) French Neo-Impressionist painter and theoretician. → p. 34.

silkscreen print *see* **screenprint**.

Siqueiros, David Alfaro (1896–1974) Mexican easel-painter and muralist. → p. 78.

Sironi, Mario (1885–1961) Italian painter associated with Novecento Italiano and Fascism. → p. 86.

Sisley, Alfred (1839–99) French Impressionist painter, especially of landscapes. → p. 30.

sketch Preparatory black-and-white or colored drawing for an artwork or building, etc., which shows the overall composition.

"Slacker" art 1990s installation art encapsulating social anomie and family dysfunction, and often incorporating a scattering of pathetic-looking objects (toys, etc.). → p. 154.

Slevogt, Max (1868–1932) German Impressionist painter and graphic artist. → p. 30.

Sloan, John (1871–1951) American Ashcan painter.

Smith, David (1906–65) American sculptor, especially in metal.

Smith, Leon Polk (b. 1906) Amer-

ican abstract Hard-Edge and shaped-canvas painter. → p. 108.

Smith, Richard (b. 1931) British Abstract Expressionist and shaped-canvas painter. → p. 108.

Smith, Tony (1912–80) American Minimalist sculptor. → p. 128.

Smithson, Robert (1938–73) American Land artist. → pp. 130–31.

Socialist Realism Realist art originating in Russia around 1932 that extolled the virtues and victories of the Communist party in the Soviet Blok. → p. 86.

Soft sculpture (Soft art) Sculpture using non-traditional, non-rigid materials.

Soulages, Pierre (b. 1919) French Abstract Expressionist painter. → p. 94.

Soutine, Chaïm (1893–1943) Lithuanian-born Expressionist painter who settled in France in 1913.

spectrum Term describing the full range of optical (perceivable) colors from red to violet.

Spoerri, Daniel (b. 1930) Swiss sculptor, Performance artist, and choreographer associated with New Realism. → p. 110.

Staël, Nicolas de (1914–55) Russo-French Abstract Expressionist painter. → p. 94.

Starr, Georgina (b. 1968) British installation artist.

Stella, Frank (b. 1936) American Abstract Expressionist painter who developed the shaped canvas. → p. 108.

Stepanova, Varvara (1894–1958) Russian Futurist and Constructivist painter and fashion designer. → p. 50.

Stieglitz, Alfred (1864–1946) American photographer. → p. 64.

Stijl, De (1917) Style and organization founded in the Netherlands

of mainly Dutch artists, whose work was based on a vocabulary of basic geometrical forms. → p. 68.

Still, Clyfford (1904–80) American Abstract Expressionist painter..

still life The representation of objects which do not move (i.e. not people or live animals), e.g. flowers, fruit, vessels, musical instruments, dead animals, etc. Does not cover landscape or abstract motifs.

Strand, Paul (1890–1976) American photographer.

Stuck, Franz von (1863–1928) German Jugendstil and Symbolist painter, sculptor, and graphic artist.

style The distinguishing characteristics of an artwork. In general, the same artistic style recurs throughout the whole œuvre or a group of works by the same artist.

Superrealism, Hyperrealism Figurative art of the 1960s that reproduced in great exactitude everyday banal subjects or consumer durables, which were often painted from photographs (Photorealism) or (in sculpture) cast from real objects. → pp. 122–5.

support The surface upon which a painting is executed (canvas, wood panel, cardboard, etc.).

Suprematism Art style developed by Malevich in Russia in 1915 based on the representation of basic geometrical motifs, which used monochrome to great effect. It was an art concerned with the systematic invention of forms. → p. 60.

Surrealism Art and literature movement founded in 1924 that sought to liberate the unconscious through the exploration of the dreamworld. → p. 80.

Sutherland, Graham (1903–80) English figurative and portrait painter, illustrator, and sculptor;

associated with Surrealism.
→ p. 106.

Suvero, Mark di (b. 1933) American metal sculptor. → p. 145.

Svanberg, Max Walter (b. 1912) Swedish Fantastic Realist painter. → p. 106.

Symbolism Art and literary current established officially in France around 1886 that treated visions and mystico-religious themes. → p. 36.

symmetry Description of a composition or artwork in which the elements of two (or more) sides are mirror-images or very similar.

Synthesism Symbolist painting style whose characteristic forms are uniform and decorative; developed in reaction to Pointillism.

Synthetic Cubism
see **Cubism.**

T

Tachisme, Tachism Movement in abstract painting beginning around 1945 in Europe. The artists painted spontaneously without prior composition or sketches, directly onto canvas with lines, swirls, flecks, and spatters. → p. 100.

Tamayo, Rufino (1899–1991) Mexican painter and sculptor influenced by Surrealism. → p. 78.

Tanguy, Yves (1900–55) French-American semi-abstract Surrealist painter. → p. 80.

Tanning, Dorothea (b. 1910) American Fantastic Realist painter and Surrealist. → p. 106.

Tàpies, Antoni (b. 1923) Spanish (Catalan) Abstract Expressionist and Informel painter and mixed-media artist. → p. 102.

Tatlin, Vladimir (1885–1953) Russian Constructivist sculptor, painter, and maker of abstract constructions. → p. 62.

tempera Opaque water-soluble paint substance made from pigment in an aqueous medium, applied to paper, cardboard, or canvas.

Ten, The Group of American Impressionist painters active 1898–1919. → p. 30.

Thater, Diana (b. 1962) American installation artist.

Thorn Prikker, Jan (Johan) (1868–1932) Dutch Art Nouveau painter.

Tinguely, Jean (1925–91) Swiss sculptor and experimental and Kinetic artist.

Tobey, Mark (1890–1976) American Abstract Expressionist and Informel painter. → p. 90.

Toorop, Jan (1858–1928) Dutch Neo-Impressionist, Symbolist, and Art Nouveau painter and graphic artist.

Torres-García, Joaquín (1874–1949) Uruguayan mainly Constructivist painter.

Toulouse-Lautrec, Henri de (1864–1901) French Impressionist graphic and poster artist, printmaker, and painter. → p. 38.

Toyen (Marie Černinová) (1902–80) Czech Surrealist painter. → p. 106.

Transavantgarde A group of Italian painters in the 1980s whose Neo-Expressionist figurative art, redolent of classic easel painting, was a reaction against Minimal art.

triptych Tripartite painting, originally a three-panel altar picture, though in modern art no longer confined to sacred art.

trompe-l'œil A style of figurative or still-life painting which seems so realistic that the viewer has difficulty in distinguishing it from the real objects on which it is based.

Twombly, Cy (b. 1928) American Abstract Expressionist painter and graphic artist.

U

Udaltsova, Nadezhda (1885–1961) Russian Cubo-Futurist painter. → p. 50.

Uecker, Günther (b. 1930) German Kinetic artist and sculptor; co-founder of the Zero movement. → p. 120.

underpainting Technique by which the support is initially coated in one or more layers of paint which impart the overall tonal atmosphere to the painting.

V

Vallotton, Félix (1865–1925) Swiss-French Nabis painter and graphic artist. → p. 38.

Vantongerloo, Georges (1886–1965) Belgian painter, sculptor, and architect; member of Abstraction-Création. → pp. 68, 82.

varnish Glossy or matt colorless transparent layer of natural resin or similar artificial solution that protects the picture surface from extraneous matter and enhances the color sheen.

Vasarely, Victor (1908–97) Hungarian-French Op art painter. → p. 120.

Vedova, Emilio (b. 1919) Italian Abstract Expressionist painter. → p. 94.

Velde, Henri van de (1863–1957) Belgian Art Nouveau painter, designer, and architect. → p. 34.

Verism Form of art in which the artist strives to reproduce the object as exactly as possible in great detail. A major trend in New Objectivity, the pictures concerned often possessed a socio-critical or plainly political content. → p. 74.

vernissage Another word for the opening or first view of an exhibition at which guests may speak to the artist.

Video art Art forms from the 1960s employing video tape in various ways: film, installations, and physical manipulation in the 1980s; and, in the 1990s, computer-aided techniques. → p. 118.

Vieira da Silva, Maria Elena (1908–92) Portuguese-born Abstract Expressionist painter active in France. → p. 94.

Vienna Actionists, Viennese Actionism [Wiener Aktionismus] A 1960s grouping in Austria of Performance and Body artists whose Happenings were centered on the deliberate breaking of social taboos. → p. 116.

Vlaminck, Maurice de (1876–1958) French Fauvist painter. → p. 44.

Vorticism British avant-garde art movement related to Futurism and Cubism; launched by writer Wyndham Lewis in 1914. → p. 54.

Vostell, Wolf (1932–98) German painter, graphic artist, and sculptor; member of Fluxus and stager of Happenings. → p. 112.

Vrubel, Mikhail (1856–1910) Russian Symbolist sculptor. → p. 50.

Vuillard, Édouard (1868–1940) French Nabis and Intimiste painter. → p. 38.

W

Wadsworth, Edward (1889–1949) English figurative painter whose work was close to Surrealism.

Wall, Jeff (b. 1946) Canadian-born photo-artist and Conceptual artist. → p. 146.

Warhol, Andy (1928–87) American Pop art painter, graphic artist, and film-maker. → p. 114.

wash Painting technique in which a drawing is partially brushed with dilute watercolor in order to represent shading or depth. Through the careful use of wash, picturesque light effects and delicate gradation in coloring can be attained.

watercolor Water-soluble paint made from color pigments dissolved in water, and applied with a brush onto paper, the image being water-sensitive and not wholly opaque.

Weiner, Lawrence (b. 1942) American Conceptual artist.

Wesselmann, Tom (b. 1931) American painter and sculptor; early exponent of Pop art.
→ p. 114.

Weston, Edward (1886–1958) American photographer. → p. 64.

Wiener, Oswald (b. 1935) Austrian Body artist member of the Vienna Actionists. → p. 117.

Wiener Schule Austrian group of Fantastic Realists. → p. 106.

Wiener Werkstätte Influential Viennese movement in the applied arts that combined Jugendstil elements and straight lines, and stressed the unity between function and form. → p. 40.

Winter, Fritz (1905–76) German Abstract Expressionist painter.

Wölfli, Adolf (1864–1930) Swiss collagist and draftsman associated with Art Brut. → p. 98.

Wols (Alfred Otto Wolfgang Schulze) (1913–51) German-born Tachist and Informel painter and photographer active mainly in France. → pp. 94, 100.

Wood, Grant (1892–1942) American Regionalist painter. → p. 84.

woodcut Print method using wood where the design is left in relief as the rest of the block is cut away.

Woodruff, Hale (1900–80)

African-American Regionalist painter.

Wool, Christopher (b. 1955) American installation artist.

World of Art [Mir Iskusstva] Russian art journal and art group (1898–1906). → p. 50.

Wotruba, Fritz (1907–75) Austrian Abstract Expressionist sculptor, designer, draftsman, and architect. → p. 96.

Wróblewski, Andrzej (1927–57) Polish Fantastic Realist painter. → p. 106.

Wünderlich, Paul (b. 1927) German Fantastic Realist painter and etcher. → p. 106.

Y, Z

Young British Artists (YBAs) Loose grouping of British artists characterized by attention-grabbing works in all media, who came to prominence in late 1980s and early 1990s, including Damien Hirst (b. 1965), Tracy Emin (b. 1963), Gary Hume (b. 1962), Dinos (b. 1962) and Jake (b. 1966) Chapman.
→ p. 116.

Youngerman, Jack (b. 1926) American painter combining naturalistic with Hard-Edge and shaped-canvas work. → p. 108.

Zadkine, Ossip (1890–1967) Russo-French Analytical Cubist and Expressionist sculptor.

Zero (group) A 1960s group of artists that left the tradition of easel-painting to proclaim a new "beginning" in the visual arts (i.e. at zero). The group had considerable influence on the development of Op and Kinetic art. → p. 148.

Zürn, Unica (1916–70), Swiss-German Fantastic Realist painter; companion of Bellmer. → p. 106.

Impressionism was a revolution in painting that opened the door for the new era of 20th-century art. The name of the style derived from Monet's canvas *Impression, Sunrise*. The young artists who held their first joint exhibition in 1874 were friends: **Cézanne, Degas, Monet, Pissarro, Renoir,** and **Sisley. Manet,** despite the allegiance he felt with the group, did not participate in the first show. ■ The Impressionists left the studio to paint in the open air, a thing almost unheard of at the time. They worked in the woods alongside the River Seine or on the northern coast of France, at the horse races, in outdoor restaurants, in cafés, theaters, and circuses. ■ The changing light that falls on figures and animals in motion demanded a brisk painting technique, for their aim was to capture the fleeting moment. The resulting pictures were suffused with a fluid, colorful, and airy atmosphere, though to most contemporary observers they simply looked unfinished. Black, gray, and brown were banned from the chromatic range in favor of the hues of the spectrum: blue, green, yellow, orange, red, and indigo. The group slowly drifted apart after its spiritual mentor, Manet, died in 1883. ■ Impressionism was subsequently important in many other countries, such as Germany, with **Liebermann, Corinth,** and **Slevogt,** and America with **The Ten** (e.g. **Hassam**). ■ Many of the great pioneers of subsequent styles worked in an Impressionist manner for a time, such as **Gauguin, van Gogh, Kandinsky, Matisse, Munch,** and **Picasso.**

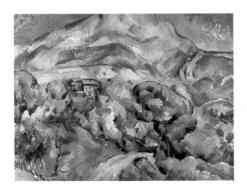

Paul Cézanne, *Mont Sainte-Victoire*, c. 1900.
Oil on canvas, 78 x 99 cm. State Hermitage
Museum, St. Petersburg.

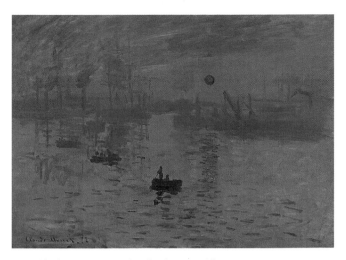

Claude Monet, *Impression, Sunrise*, 1872. Oil on canvas,
50 x 65 cm. Musée Marmottan, Paris.

Impression, Soleil levant [Sunrise] was the title Monet gave to this
early morning view of a harbor painted in 1872, and shown in the
1874 group exhibition held in the studio of the pioneer photo-
grapher, Nadar, in Paris. The critics scoffed at the unfamiliar sketch-
iness of such works by calling them mere "Impressionism." Thus
the revolutionary style that marks the inception of modern art was
christened.

The prime characteristic of Impressionist pictures was that they
were executed in the open air, in front of the motif. They captured
the momentary effects of evanescent sunlight, shadow, atmos-
phere, and movement. Instead of being mixed on the palette, the
colors were often applied straight and unmixed to the canvas in
short strokes of varying shape placed next to one another, so that
they merged together into a new color in the viewer's eye. The con-
tours of things were no longer emphasized, and perspective no
longer played a structuring role. The result was a use of bright col-
ors and quick brushstrokes which lent Impressionist paintings a
rough, unfinished appearance by comparison to traditional oils.
Everything was rendered with a sweeping vividness.

When Impressionist painting began in 1874, the sculptor **Rodin** was thirty-four years old. He was to work in the context of the Impressionists for the rest of his career, his sculptures being publicly shown for the first time in conjunction with canvases by Monet. ■ The key painterly characteristics of Impressionism—an emphasis on light and shade, mood and motion, and the capturing of a passing moment in time—also played a part in works by Rodin. ■ With their innovative poses and surface treatment they replaced the realistic, smoothly crafted, academic sculpture of the day and opened unprecedented possibilities for sculptural art. ■ Figures and portraits were now freely interpreted, gestures and facial features often exaggerated, sometimes even distorted, in order to emphasize individual characteristics or to heighten expression. ■ Rodin is considered the most significant sculptor of Impressionism. His work had a great influence on the subsequent styles of Symbolism and Art Nouveau. ■ Only a handful of sculptors besides Rodin made a name for themselves during that period. Among them were **Claudel**, **Rosso**, and the painter–sculptors **Degas** and **Renoir**.

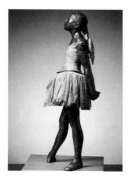

Edgar Degas, *Little Fourteen-Year-Old Dancer*, 1879–81. Bronze and fabric, height 95.2 cm. Musée d'Orsay, Paris.

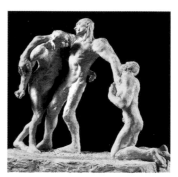

Camille Claudel, *The Age of Maturity*, c. 1894. Plaster, 87 x 100 x 53 cm. Musée Rodin, Paris.

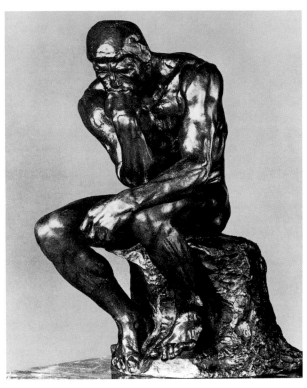

Auguste Rodin, *The Thinker*, 1904. Bronze, 180 x 108 x 141 cm.
Musée Rodin, Paris.

The Thinker is doubtless Rodin's most celebrated work. Its first ver-
sion, executed in 1881, was originally conceived as a relief figure for
The Gates of Hell, a door decorated with many figures, which was to
be installed at the Musée des Arts Décoratifs in Paris.

NEO-IMPRESSIONISM

The style known as Neo-Impressionism was conceived in opposition to an Impressionism that was perceived to have become routine. Many artists of the time now thought Impressionism was indeterminate, arbitrary, and lacking in formal properties, and so set out to find a way to impart greater order to their compositions, preferably on a scientific basis. The forerunner in this regard was **Seurat**, whose canvas, *Sunday Afternoon on the Île de la Grande Jatte*, exhibited in 1886, became the icon of a new color theory, a new painting technique, and a new approach to composition. ▪ The circle of young painters was small when they joined to form a group in 1886: Seurat himself, with **Signac**, **Cross**, and former Impressionist **Pissarro**. Like the Impressionists, they found their motifs in nature, but they executed only drawings and color designs outdoors, completing the oils in the studio. Nothing was left to chance, and they chose an ordered color scheme before applying a single brushstroke: this was indeed painting according to scientific principles. ▪ The painted surfaces were dissolved into thousands of tiny strokes and dots. The motif was reduced to essentials and simplified from its outward appearance, while the composition appeared strictly organized. Having been applied unmixed and often as paired complementaries, the fractured colors scintillated and vibrated with optical interference. Unpainted portions of the canvas shone through the strokes and dots, the motif only coming together when seen from a distance. ▪ Certain Neo-Impressionist works also adhered to **Pointillism**, a term deriving from the dots of paint (in French, *points*) used in the technique. An alternative name for the Pointillist movement is **Divisionism**, which referred to the scientific separation of the chromatic areas. ▪ Neo-Impressionism was strong in Belgium (**Finch**, **Henry van de Velde** and **van Rysselberghe**). An influence on Futurism, *Divisionismo* in Italy was more Symbolist in intent, **Pellizza da Volpedo** being particularly productive. The Neo-Impressionist group in France began to break up in 1891, following the premature death of its figurehead, Seurat. Though its influence on subsequent developments in art would be immense (on Matisse, for example), few artists remained true to the spirit of the style for long.

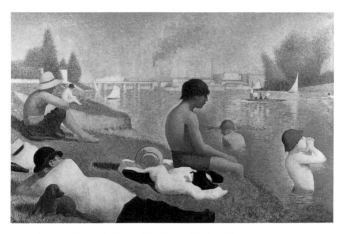

Georges Seurat, *Bathers at Asnières*, 1883–84. Oil on canvas, 201 x 301.5 cm. The National Gallery, London.

Seurat composed this oil on the basis of a great number of drawings, detailed sketches, and studies made in situ. Leaving nothing to chance, he stuck closely to a preconceived plan.

Seurat thought it absolutely essential to establish clear and cogent formulations for the rules governing harmony, line, light, and color. He did not begin to paint until he had established the general arrangement of figures, objects, and landscape in his mind's eye. Yet, in spite of the composition's precise order, the painted surface itself is extremely vital, conveying all the shimmer and brilliance of sunlight on a fine summer's day.

SYMBOLISM

Symbolism began as a literary movement that emerged in France and soon spread throughout Europe. In 1884 the French author Joris-Karl Huysmans published *A Rebours* [Against the Grain], which became a seminal work of Symbolist aesthetics. The decisive step in painting was taken in 1886 by **Gauguin**. ■ Like Neo-Impressionism, Symbolism was a reaction against Impressionism and its adherence to appearances. New themes came to the fore—evocations of feelings, dreams, and visions. Symbolist artists were not searching for a new style as such, but more for a method of exploring the realm of the imagination and delving into the depths of the subconscious mind: mysticism and religious experience were turned into a rich source of content. The artists also abandoned painting out of doors, returning to the quiet of the studio. ■ The œuvres of three Frenchmen—lone wolves who belonged to no group—heralded the new style: the dreamscapes of **Puvis de Chavannes**, the bejeweled surfaces of **Moreau** (who taught Rouault and Matisse), and the fantastic visions of **Redon**. Their works influenced a circle of younger artists who took up the Symbolist banner. Their leader was Gauguin, whose disciples included **Anquetin** and **Bernard**. During the 1889 Exposition Universelle they presented Symbolist art to the public for the first time. ■ Comparing Symbolist pictures with those of the concurrent Neo-Impressionism, the extent to which style and content differs becomes obvious. Symbolist compositions are often dominated by large flat areas of color, figures and motifs are outlined in dark contours, the palette is bright and intense, the colors strong and evenly applied. The influence of Japanese color woodblock prints is apparent, as are stylistic elements borrowed from Egyptian and Greek art, and even hints of the decorative, idealized figure treatment of folk art. ■ It had a profound influence on the development of the Nabis and, outside France, on late British **Pre-Raphaelitism** (as in Burne-Jones), Ensor, and Munch. Symbolism was extraordinarily prevalent throughout Europe, from Poland (**Malczewski**) to Belgium (**Frédéric**) and Italy (**Segantini**), as well as in America (**Ryder**).

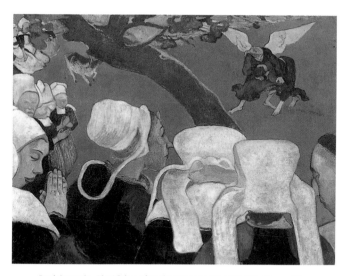

Paul Gauguin, *The Vision after the Sermon*, or *Jacob Wrestling with the Angel*, 1888. Oil on canvas, 73 x 92 cm. National Gallery of Scotland, Edinburgh.

Gauguin's painting depicts country women after a Sunday service experiencing a vision of Jacob, the begetter of Israel, as he struggles with the Angel.

It is a dramatic composition in which a diagonal tree-trunk separates the reality of the foreground from the imaginary realm in the background where the vision appears. The picture is dominated by the red of the soil, the black and white garb of the Breton peasant women, and the symbolic colors of green, blue, and yellow in the wrestling figures.

The image well illustrates what was new about this approach to painting: intensification of color and simplification of form. Symbolist artists initially concentrated on the traditional genres of landscape and still-life. Yet as they grew intrigued by the new ideas of the Symbolist poets and thinkers, more strictly literary themes made an appearance.

THE NABIS

The word "Nabis" comes from the Hebrew and means "prophets." It was the name chosen by a group of young painters who emerged from Symbolist circles and exhibited together for the first time in Paris in 1889. Their aims, as with the Symbolists, were directed against **Naturalism**. ▪ The Nabis' discussions often revolved around esoteric science and occult religion, around symbolism and synthesis, and concerned the merging of parts into a greater whole. ▪ They treated as gospel Gauguin's assertion that painting should strive for a higher reality than that revealed by sensual perception. **Sérusier** served as an intermediary between Gauguin and the Nabis group, whose youthful members, all aged between twenty and thirty, included **Bonnard, Denis, Roussel, Vallotton,** and **Vuillard**. ▪ They were very different personalities, but all were open-minded and interested in all things progressive, and were driven by enthusiasm and idealism. In fact their ideas outstripped the current thinking of the period, earning them the novel epithet of "avant-garde." The Nabis' work combined symbolic and decorative styles into a new, anti-naturalistic art. The evocation of three dimensions and of depth was abandoned in favor of two-dimensionality, with an emphasis on the flat picture plane. The compositions incorporated precise contours filled with broad expanses of color. In their various ways, all the Nabis attempted to make the viewer realize that their pictorial statements did not constitute realistic representations but visions. ▪ Their drawings and lithographs were particularly out-

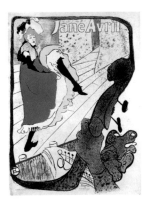

standing and sparked an entirely new style of illustration. Alongside Bonnard and Vallotton, the master was **Toulouse-Lautrec**, who was only loosely affiliated to the Nabis. The renowned era of French poster art had begun, which—for better or worse—marked the onset of advertising's triumphant march around the globe.

Henri de Toulouse-Lautrec, *Jane Avril*, 1893. Color lithograph, 124 x 91.5 cm.

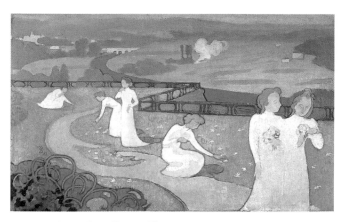

Maurice Denis, *April*, 1892. Oil on canvas, 37.5 x 61 cm.
Rijksmuseum Kröller-Müller, Otterlo.

The subject of this picture carries echoes of Symbolism, but the sin-
uously curving path and ornamental plants in the left foreground
already bear the traits of the emergent Art Nouveau. The painted
areas show few signs of visible brushwork or modulation, while per-
spective is indicated solely by the diminishing size of the figures.
Even the distant landscape is rendered in warm reds and ochers
that appear to advance towards the eye. Everything is suffused in
soft, subdued hues imbued with harmony.

Modeling and spatial values are toned down in favor of two-dimen-
sionality. The Nabis' aim was to express their dreams and feelings,
their fantasies and religious faith through painting, rather than to
imitate nature. They wanted art to regain the innocence it had had
in its early beginnings. Denis went so far as to open an Atelier for
Sacred Art, which would prove to have a considerable influence on
the development of Christian art in Europe.

It was also Denis who advanced the famous postulate that a paint-
ing, before being a war-horse, a nude woman, or some anecdote or
other, was first and foremost a plane surface covered with colors
arranged in a given order.

ART NOUVEAU AND JUGENDSTIL

The epoch of Symbolism and the Nabis came to an end around 1900, by which time the Art Nouveau movement (c. 1890–1910) had been underway for some ten years. As this overlap indicates, the artists working in the three styles shared a number of presuppositions and approaches. ▪ The principal aim of Art Nouveau was initially to unify the arts to produce a *Gesamtkunstwerk* [total work of art]. The first step in this direction had been taken in England, where the **Arts and Crafts movement** set out to beautify everyday objects. Thus the notion of a lifestyle suffused with aesthetic considerations was born. ▪ In painting, the emphasis lay on a combination of representational and decorative elements. Artists concentrated on contour and ornamentation, with swirls, curlicues, and arabesques. The colors within the outlines were applied smoothly and flatly. The compositions displayed a balanced interplay of lines, shapes, and colors. Bright hues were used sparingly, but, when acting as accents surrounded by subdued tones, they could shine like gemstones. The prevailing color was blue, employed symbolically to convey a dreamlike, fairy-tale mood or a sense of melancholy. ▪ Major Art Nouveau themes included childhood and youth, marriage and motherhood, poetry and music, love and beauty. The most striking feature of Art Nouveau painting is its use of florid ornament. Initially derived from forms in nature and known as the Floral Style, it soon developed into pure, non-referential shapes, and a more abstract ornamental style was born. This development led straight to the pure abstraction of Kandinsky. ▪ In German-speaking lands, the movement is known as Jugendstil and made increasing use of the straight line, leading in Vienna to the **Wiener Werkstätte** style of applied art and architecture. In Vienna Secession painting particularly, compositional structure took on a special importance. Figures were often cut off at the edge of the picture or at the hips; heads stopped at the forehead—only that portion of the subject was rendered which was important for its emotional message.

Art Nouveau ornament.

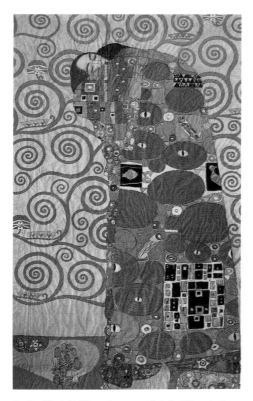

Gustav Klimt, *Fulfillment*, 1905–11. Detail of frieze in the
Palais Stoclet, Brussels. Tempera, watercolor, crayon,
gold, silver on wrapping paper.

Art Nouveau pictures are characterized by a strong emphasis on the
ornamental. In this example of Viennese Jugendstil, the subject—a
couple locked in an embrace—recedes in importance compared to
the predominant expanses of color overrun by swirling floral and
abstract patterns. While the background is covered with an organic
pattern of tendrils, the male figure's cloak already exhibits the
abstract ornamental style. The rectangular and oval shapes are
entirely non-objective and as such anticipate the advent of early
abstraction.

DIE BRÜCKE AND EXPRESSIONISM

The pioneers of Expressionism in Germany were three artists who met as students of architecture in Dresden and in 1905 founded a group called Die Brücke [The Bridge]. They were **Heckel**, **Kirchner**, and **Schmidt-Rottluff**, being joined in 1906 by **Pechstein** (and for a brief period by **Nolde**), and then in 1910 by **Mueller**. ▪ The new style stressed the expression of emotional reactions to the artists' subject matter and it became known as Expressionism in 1911. ▪ The art of Die Brücke differed markedly from that of previous periods. Natural forms were simplified and removed from their objective context, sometimes to the point of being unrecognizable. Contours were drawn in heavy, slashing brushstrokes and the forms brightly colored. Many Expressionist pictures had a raw, consciously primitive look, heightened by contrasts of complementary colors that mutually strengthened each other. ▪ The Expressionists' subjects were not vague or enigmatic, but taken from daily life, and their landscapes were frequently painted from nature. Yet although the visible world provided their point of departure, such artists maintained that the essence of things only emerged through emotion and instinct. Their portraits and figures give the impression of having been mercilessly stripped bare, body and soul. Their landscapes seem constructed of radically reduced forms and possess a compelling, commanding monumentality. The sculpture too was powerful, often primitive-looking, or carved directly from wood and sometimes

roughly painted. ▪ In 1913, after only eight years, Die Brücke dissolved. The largely homogeneous style that had resulted from close collaboration now gave way to more individual approaches. Yet though their pictures became increasingly personal, the Brücke style continued to mark the work of all its former members throughout their careers. ▪ The significance of Die Brücke for the development of modern German art was immense.

Karl Schmidt-Rotluff, *Blue-Red Head*, 1917. Stained wood, height: 30 cm. Brücke Museum, Berlin.

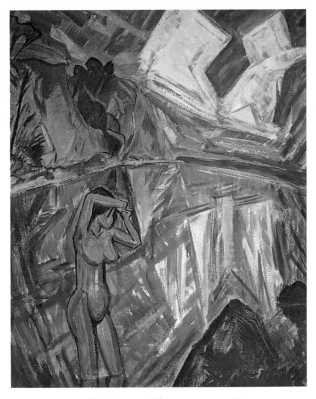

Erich Heckel, *Crystalline Day*, 1913. Oil on canvas, 120 x 96 cm.
Staatsgalerie Moderner Kunst, Munich.

The mirroring of the sky and clouds in the water below and the
angular, sharp-edged shapes with their saturated colors lend extra-
ordinary expressiveness to the composition. Light, too, plays a key
role: "The landscape appears splintered into crystalline, ringing
fragments."

FAUVISM

The group of French artists known as the Fauves was established in 1905. It comprised **Matisse**, at thirty-six the eldest and the group's spokesman, **Derain**, **van Dongen**, **Dufy**, and **Vlaminck**. The name Fauves, or "Savages," derived from what was seen as the untamed, primitive style of these artists who held their first group show in 1905. Their association was only a loose one, as they had neither a program nor a consistent aesthetic theory. Yet they did share a common intention, which led to a certain consistency of style. ■ Impressionism and Symbolism were still very much in the air when the Fauves chose Cézanne as their ideal. From him they learned how to establish a solid compositional framework, while the vitality of van Gogh's work inspired the use of rapid, oblique brushstrokes, and Seurat pointed the way to a reliance on pure, unmixed colors. ■ Impressionist light, too, made a reappearance in Fauvist art. Their work was freed from representing real phenomena, liberated from theories of any sort, and uncompromising in its rejection of outside influences. The message was no longer in a particular subject or motif, but consisted solely of an interplay of color, plane, and line on the canvas. This epitomized the Fauves' reaction against everything "that resembled a cliché lifted from life." The luminosity of Fauvist pictures derived from a juxtaposition of complementary colors. The employment of pure, unmixed hues was pushed to its very limits. The youthful age of the Fauves was reflected in an art of refreshing vitality, though they remained together as a group for only two years. Believing they had said everything they had intended through their art, they went their separate ways. ■ Only Matisse continued to paint in a similar style, though in a way tempered, as he grew older, by a lucid reduction of form.

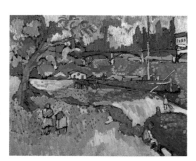

André Derain, *Le Pecq, le port*, c. 1905. Oil on canvas, 65 x 81 cm. Fondation Beyeler, Riehen.

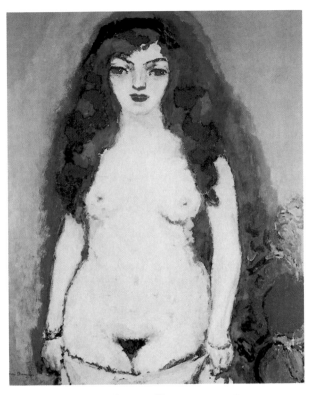

Kees van Dongen, *Nude Girl*, c. 1907. Oil on canvas, 100 x 81.5 cm.
Von der Heydt-Museum, Wuppertal.

Van Dongen's paintings display all the characteristics of Fauvist art,
from a brilliant palette and dynamic brushwork to the agitated con-
tours of the figure. Like many others in the group, he launched into
his compositions without preliminary sketches or drawings. Also
like them, he frequently squeezed paint directly from the tube onto
the canvas and then spread it, unmixed, with the brush.
The result was an art of great spontaneity whose immediate
approach and often non-realistic color schemes made Fauvism a
revolutionary influence in the early years of the twentieth century.

The group of artists who initiated Cubism in 1907 was small, but they profoundly influenced the development of modern art in Europe. Their predecessors were Cézanne, Derain, and Matisse. Their prime concerns were a striving for formal order and a concentration on a small range of pictorial themes. Based in France, the movement's pioneers were **Picasso** and **Braque**. In the second phase of Cubism, which began about 1913, they were joined by **Gris** and **Léger**. Together they translated Cézanne's statement that natural forms were fundamentally spheres, cylinders, and cones, into a new pictorial language. This reduction to geometrical shapes gave the new style its name, Cubism. ▪ No longer were natural appearances imitated in art or depicted according to the laws of perspective. The motifs in Cubist pictures lay in the two-dimensional plane and were reduced to geometrical forms or small interlocking facets. The range of subject matter was limited to trees and houses, objects from everyday life, and nude figures. Another characteristic feature was the simultaneous depiction of objects from several viewpoints at once, giving the viewer the impression of being able to see through and behind the objects in the painting. ▪ The first phase of Cubism, in which the artists still tended to abstract from real things, was known as **Analytical Cubism**. The

second phase, from about 1913 onwards, came to be termed **Synthetic Cubism**. Now, instead of taking reality as their point of departure, artists began to build their compositions out of free, semi-abstract forms. This period also saw the introduction of collage, the pasting of pre-existing materials, such as pieces of newspaper, textiles, and wallpaper, onto a painted composition. These fragments of everyday life, removed from their normal function, became integral parts of the picture and thus were raised to the level of art.

Georges Braque, *Man with Guitar*, 1914.
Oil and sand on canvas, 130 x 72.5 cm.
Musée National d'Art Moderne,
Centre Georges Pompidou, Paris.

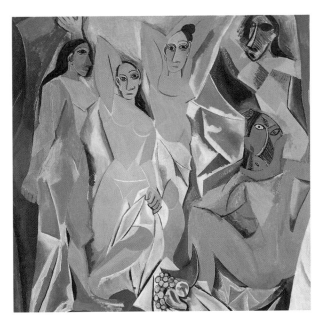

Pablo Picasso, *Les Demoiselles d' Avignon*, 1907. Oil on canvas, 244 x 233.7 cm. The Museum of Modern Art, New York.

The perspective employed in this picture no longer suggests spatial depth. The figures and accessory objects, such as the table with fruit and curtain, are all arranged in a single plane. Nor does the background really seem to lie behind them. All of the pictorial elements are composed of more or less geometrical shapes. This painting marked a radical departure from traditional styles and constituted the first step towards Cubism, at the same time introducing a new era in art.

The invention of Cubism by Braque and Picasso established a pictorial language on which nearly all of 20th-century art subsequently built. The painters who initiated the style in Paris in 1907 were joined around 1910 by the sculptors **Laurens**, **Duchamp-Villon**, and **Lipchitz**. These artists declared themselves to be "realists" in the sense that they set out to represent the real world in their work, but believed traditional methods inadequate to the task. ■ The transformation of natural appearances into an independent visual idiom proved to be a formidable challenge. For though nature was to be re-shaped, the point of departure was still to remain recognizable in the finished work. Cubist sculpture thus became an art based on a concept in which sculptural form was abstracted from actual appearances. The motifs were frequently built up of wooden or metal elements, or carved in stone, and occasionally painted. Such sculpture was designed to be viewed from all sides in order to grasp the way their separate components interlocked to form a three-dimensional whole. ■ When the First World War broke out in 1914, the group dispersed. Although their approach was taken up again after 1918, the force of the original ideas was unmatched.

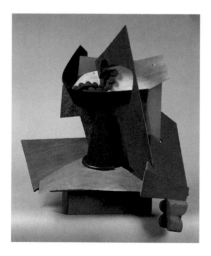

Henri Laurens, *The Bowl of Grapes*, 1918.
Painted sheet metal and wood, 68 x 62 x 47 cm.
Collection of M. and Mme. Claude Laurens, Paris.

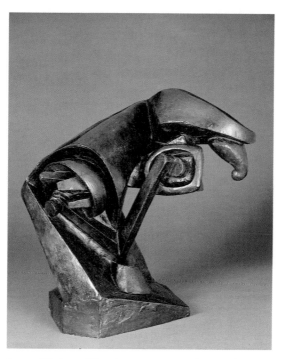

Raymond Duchamp-Villon, *Horse*, 1914. Bronze (cast 1976),
43.5 x 44 x 26 cm. Musée National d'Art Moderne,
Centre Georges Pompidou, Paris.

This visual evocation of a horse still hints at a real animal, but its configuration is so unfamiliar as to be almost unrecognizable. In this highly imaginative piece, the horse's limbs have metamorphosed into mechanical parts such as connecting rods, wheels, and ball bearings. Here Cézanne's declaration that nature consisted of spheres, cylinders, and cones has been translated almost literally into autonomous sculptural form.

The static compositional elements are ousted by an evocation of kinetic motion and energy, a feature also central to the art of the Italian Futurists.

RUSSIAN ART: CHANGE AND REVOLUTION

By the end of the 19th century, art in Russia was subjected to much the same forces as elsewhere: **Realism**, Symbolism, and **Academicism**. In Russia, however, Realists such as **Repin** had popularized art in a way rare in Europe, and throughout the period folkloric art was a vibrant source of inspiration, while organized groups and schools remained important. ▪ The St. Petersburg-based **World of Art** [Mir Iskusstva] group (1898–1906) and journal imported Symbolist currents, seen in the work of **Benois**, **Serov**, **Bakst** (in his costume and set design for Diaghilev's "Ballets Russes" in 1909), and the sculptor **Vrubel**. The **Blue Rose** [Golubaia Roza] group founded in 1907 produced predominantly Symbolist and Fauvist paintings, such as those by **Kuznetsov**. Russian modernism proper however took off when the couple **Larionov** and **Goncharova** dominated the 1910 *Golden Fleece* show with works that combined fiery coloring and graphic-inspired layout. They were among the founders of the **Jack of Diamonds** society whose first show also included works by **Malevich**. Larionov and Goncharova left this Cézanne-influenced group to set up the **Donkey's Tail** group that introduced **Neo-primitivism**, a modernist approach to the peasant-inspired popular prints known as *bubok*. ▪ Malevich's **Cubo-Futurism** at the Donkey's Tail and Target shows (1913) combined those styles with Expressionist coloring, whereas Larionov's **Rayonism** operated a synthesis of Orphism, Futurism, and mystic light theories. **Lentulov** combined near abstraction with Expressionism (1912–14). Other works included abstracts by **Kandinsky** and portraits by **Jawlensky**. In **Exter**, **Popova**, **Rozanova**, **Stepanova**, and **Udaltsova**, Russia also possessed an extraordinary concentration of women artists. ▪ At the Revolution, art became intimately linked to politics with Agitprop and the artistic institutes: Somas for technical arts with Constructivism (with **Pevsner**, **Tatlin**, and **Gabo** on its staff), and AKhRR (1920), which retreated into what became known as Revolutionary Realism. By the 5x5=25 Moscow show (1921), easel painting was being discredited in favor of design. Russian folk art continued to influence **Chagall**, **Filonov**, and **Falk**. Post-Bolshevik art is essentially a story of increasing state control and academicism (e.g. the Society of Easel Painters), resulting in the exile of many artists.

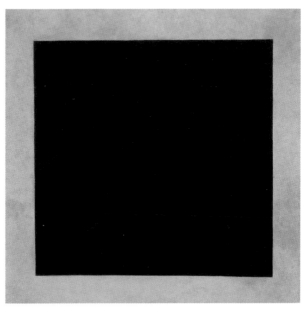

Kasimir Malevich, *Black Square on a White Ground*, c. 1929. Oil on canvas, 106 x 106 cm. State Russian Museum, St. Petersburg.

This is a replica or reworking of the painting of the same name of 1915 which formed the centerpiece of Malevich's "rediscovery of pure art" that he called **Suprematism**. Other monochrome works and squares on grounds of the same tone included an even more daring *White Square on a White Ground* (1919) that heralded Minimalism and Hard-Edge.

ABSTRACT ART

The term abstract art became current around 1910. It was used to describe pictures that contained no reference to real objects and that no longer relied on an imitation of nature. Abstract art is also referred to as Non-Objective art, especially in a European context. The inception of abstraction in art can be traced back as far as the middle of the 19th century, for instance to the English artist J.M.W. Turner. His landscapes of around 1840 already contained hints of non-objectivity, and many of his color sketches seem devoid of reference to the external world. ■ In 1910 in Munich, the Russian-born artist **Kandinsky** painted his first abstract picture. At the time he was also writing a book, *On the Spiritual in Art*, the first theoretical treatise on form and color in abstract art. ■ There are two fundamentally distinct approaches to abstraction. One is the geometrical, as seen in the work of **Mondrian**, **El Lissitzky**, and the Constructivists. The other is more emotional and dependent on inspiration and inward vision, and is represented by the early work of **Kandinsky**, **Kupka**, and Americans such as **Hartley**. Subsequently the streams of art subsumed under the term abstraction spread rapidly and were logically developed by scores of younger artists. To this day abstraction, in its countless variations, remains as vigorous as ever.

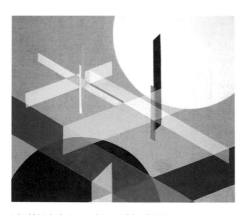

László Moholy-Nagy, *Composition Z VIII*, 1924.
Distemper on canvas, 114 x 132 cm. Neue Nationalgalerie, Staatliche Museen zu Berlin–Preussischer Kulturbesitz.

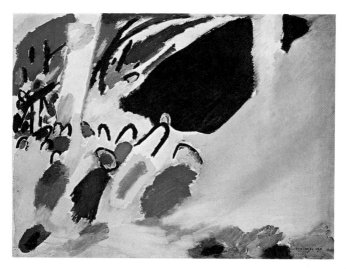

Wassily Kandinsky, *Impression III (Concert)*, 1911. Oil on canvas, 77.5 x 100 cm. Städtische Galerie im Lenbachhaus, Munich.

In this painting a concert hall is evoked by means of graphic marks with a few strokes of black rapidly brushed in. The large, trapezoid area of black represents a grand piano, and the curved outlines, some filled in with color, are the audience. At least this is one possible interpretation of Kandinsky's composition. What we do know for certain is that it was inspired by a performance of Arnold Schoenberg's avant-garde music held in Munich in 1911.

Objects and human figures are still recognizable here. Yet soon Kandinsky would increasingly divest his works of all objective reference, and finally launch into pure abstraction.

FUTURISM

The movement known as Futurism began in 1910 in Italy. It arose out of opposition on the part of young artists, in this case against the contemporary art of their country, which they felt had lapsed into inertia. Their spokesman was the writer Filippo Tommaso Marinetti, who publicly expounded and defended the artists' ideas.
■ The founding members of the movement were **Balla**, **Boccioni**, **Carrà**, **Russolo**, and **Severini**. Bound by an unshakable faith in the world to come, they dubbed themselves Futurists. ■ They were intrigued by technological innovations of every sort, from automobiles, airplanes, and motorcycles to heavy machinery and electric lighting. Setting out to depict the beauty of technology, they attempted to evoke visually speed and motion. ■ The invention of moving pictures gave the Futurists the idea of depicting the movement of human figures, animals, and machines, not singly and frozen in time but as a simultaneous sequence. It was an attempt to add a kinetic dimension to what is essentially a static art. A further Futurist concern was to render visible sounds and even odors. All in all, they set out to capture pictorially the simultaneity of sense perception. The outbreak of war in 1914 practically brought the movement to an end. ■ Futurism exerted great influence in Britain. If **Nevinson** remained orthodox, **Lewis**, seeking to introduce plastic values into Futurism, created his own movement, **Vorticism**, in 1914. **Epstein's** *The Rock-Drill* (1913–15), for example, shows its machine aesthetic in sculpture.

Luigi Russolo, *House + Light + Sky*, 1912–13. Oil on canvas, 100 x 100 cm. Öffentliche Kunstsammlung, Kunstmuseum, Basel.

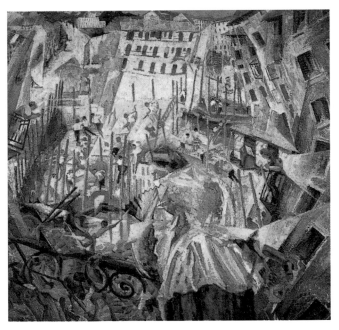

Umberto Boccioni, *The Noise of the Street Penetrates the House*, 1911. Oil on canvas, 100 x 100 cm. Sprengel Museum, Hanover.

Boccioni's composition depicts the impression one has upon opening a window on a city street and hearing the noises rising from below. In a series of superimposed motifs, the artist depicts the scurrying people and animals, workmen balancing on scaffolding, and building facades tilting in all directions, all rendered in garish colors. The scene is pervaded by a brash restlessness that communicates itself to the viewer, whose eye has to flit about, unable to find any resting place. Like Futurist paintings in general, this one represents an attempt to convey modern life in all its dynamism.

THE BLUE RIDER

The artists' association known as Der Blaue Reiter, or the Blue Rider, was formed in Munich in 1911 by **Kandinsky** and **Marc**. It was a loosely allied group of painters who had known each other since their membership in the Neue Künstlervereinigung München [New Artists' Association of Munich] several years before. Other members were **Jawlensky**, **Klee**, and **Macke**. They were joined in 1913 by **Feininger**. ■ The origin of the name Blue Rider is not entirely clear. It may have derived from Marc's preference for the color blue and from a favorite motif of Kandinsky's, men and women on horseback. ■ The artists in the group were widely read and interested in philosophy. Yet despite a taste for theory, their primary aim was to reveal through painting their feelings, sensations, and visions. Great sensibility and an attempt to penetrate to the essence of natural phenomena characterized their work. By dispensing with verisimilitude they gained the freedom to work on an ever higher level of abstraction. ■ Subject matter declined in importance compared to composition, color, and form. Analogies were sought in music, as the artists spoke of color chords, color sounds, and of the orchestration of color. This was accompanied by an emotional lyricism which made their pictures profoundly moving, capable, as one Blue Rider artist said, of "reverberating in the soul" of the viewer. ■ Yet no attempt was made to predetermine the viewer's reactions. The point was simply to elicit a response of whatever kind and, through the expressive force of painting, to create a spiritual link between artist and viewer. ■ In the midst of the Blue Rider's most productive phase, the First World War broke out, and after only three years of existence, the group dispersed. The war was to dash the hopes and futures of an entire generation.

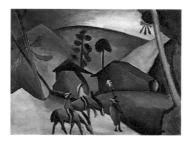

August Macke, *Indians on Horseback*, 1911. Oil on wood, 44 x 60 cm. Städtische Galerie im Lenbachhaus, Munich.

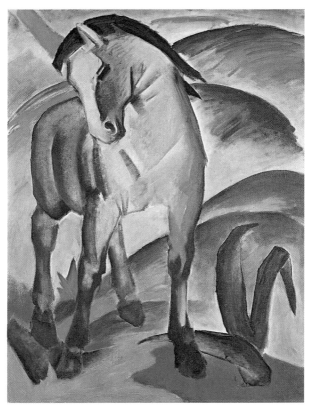

Franz Marc, *Blue Horse I*, 1911. Oil on canvas, 112 x 84.5 cm.
Städtische Galerie im Lenbachhaus, Munich.

For Franz Marc, horses were symbols of power and endurance. He
associated them with the color blue because he considered this the
color of spirituality. In his eyes, art was a symbolic language whose
roots lay in the mystery of nature.
Blue Horse I is an image of great harmony and an example of the
significance of animals as a subject in Marc's art.

French Orphism emerged concurrently with Cubism and Futurism in the 1910s, and was closely related to both. The name of the movement was coined by the French poet Guillaume Apollinaire, in allusion to Orpheus, the singer in Greek mythology. Apollinaire saw an analogy between this painting style based on harmonious color combinations and the harmonies of music. ■ Orphism was developed by three artists, **Robert Delaunay**, his wife **Sonia Delaunay**, and **Kupka**. In contrast to the static compositions and subdued palette of the Cubists, the Orphists emphasized movement and luminous colors. Yet they also adopted certain essential features of Cubism, such as the reduction of natural forms to cubic and geometric planes, and the division of elements into facets. They often depicted swirling shapes in pure colors, evoking vortices that gleamed in all hues of the spectrum. These harmonious compositions were paeans in praise of color. ■ When artists began to dispense with recognizable objects the result was a quantum leap in art, and the door to abstract painting now opened in France as well. ■ The influence of this small group on other artists was great. In Germany, it was especially the Blue Rider painters who maintained close contacts with the Orphists, studied their ideas, and introduced them into their own art. ■ This group, like the Blue Rider, dissolved when war engulfed Europe.

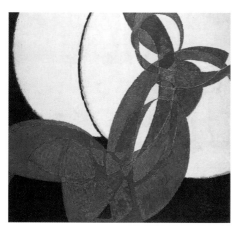

František Kupka, *Amphora. Fugue in Two Colors*, 1912.
Oil on canvas, 211 x 200 cm. Národni Gallery, Prague.

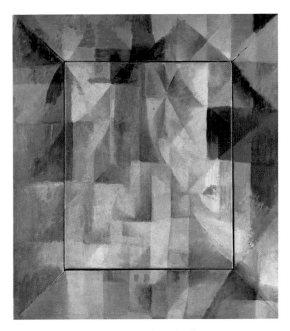

Robert Delaunay, *Fenêtre simultanée sur la ville*, 1912.
Oil on canvas and wood (painted frame), 46 x 40 cm.
Kunsthalle, Hamburg.

Delaunay concerned himself intensively with simultaneous con-
trasts of color. He understood the reciprocal influence of colors
placed next to each other, with the one appearing to increase the
other's brilliance. This optical phenomenon had been discovered
back in 1839 by the French physical chemist Michel Eugène
Chevreul, but Delaunay was the first to make conscious use of the
effect in painting.
Many artists were influenced by his employment of color, such as
the painters of Die Brücke and the Blue Rider, all the way down to
the Color Field painters of the 1950s.

The Russian movements known as Constructivism and **Suprematism** reached their apex around the year 1915. Protagonists included the painters **El Lissitzky** and **Malevich**, and the painter-sculptors **Gabo**, **Pevsner**, and **Rodchenko**. ▪ These artists distrusted objective art because they distrusted the world it represented. "Works of art are not mirror images of nature," they declared, "but new facts." The most radical break with tradition was achieved as early as 1913 by Malevich, who called his art Suprematism, in the firm belief that it represented the highest possible form of art. The blanket term Constructivism describes the work of the group as a whole and its emphasis on constructed, geometrical, and technical elements. ▪ Trapezoids, ellipses, circles, squares, rectangles—the entire range of two-dimensional geometrical shapes—were arranged on the ground of the painting vertically, horizontally, diagonally. The background was usually rendered in a single, light, neutral hue, creating the impression that the shapes were floating in infinite space. Later these forms were supplemented by three-dimensional bodies such as cubes, spheres, or pyramids.

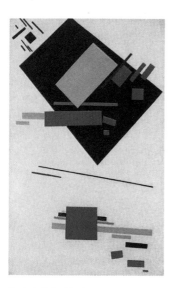

▪ Constructivism is the 20th-century style which ventured farthest from a representation of organic nature. It was an art of invention, an art engineered, as it were, out of crisply contoured shapes painted in bright, emblematic colors; yet the result was redolent with harmony and aesthetic beauty. ▪ The movement came to an end around 1921. In the space of only eight years it had brought forth outstanding works which exerted a profound influence on many subsequent currents in art.

Kasimir Malevich, *Suprematist Painting*, 1915. Oil on canvas, 101.5 x 62 cm. Stedelijk Museum, Amsterdam.

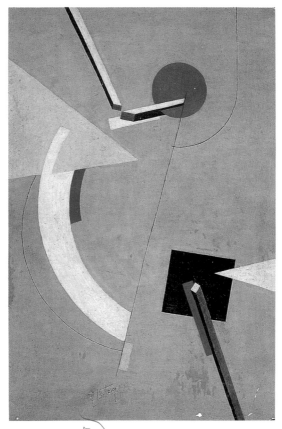

El Lissitzky, *Proun*, 1923. Tempera on paper, 61 x 40 cm.
Museum Ludwig, Cologne.

El Lissitzky was trained as an engineer and architect. One of his axioms concerned the unavoidable effect which technology was to have on contemporary artists. The Constructivist pictures he produced from 1919 onwards were titled *Prouns*, derived from the Russian word *prounovis*, which loosely translated, means "towards a renewal in art."
The artist's compositions are built up of elements that call to mind drawings of architectural sites or ground plans transferred from drawing board to canvas.

CONSTRUCTIVISM SCULPTURE

The heyday of Russian Constructivist painting in 1915 also saw the emergence of sculptures in this style, "constructions in space," as their makers termed them. ▪ Four names stand out here: **Gabo**, **Pevsner**, **Rodchenko**, and **Tatlin**. Their idea was to put paid to those trends in art which, after twenty years' research, had reached a cul-de-sac, in particular Cubism and Futurism. The Constructivists declared, "space and time are the sole forms in which life builds itself, and therefore art must build on them as well." ▪ They set out to design objects in space, things that existed beyond all the narrative and illusion-making of traditional sculpture. These objects were not intended to refer to anything else, but to be sufficient unto themselves. No sculptors had ever before departed so radically from the accepted norms of their art. ▪ Their example found many emulators in the Western world, including the Bauhaus artists in Germany and those of De Stijl in Holland. Fifty years later Constructivism would experience a new lease of life in the kinetic objects of Op art. ▪ In 1921 this abstract art in the service of the revolution began to be supplanted by an art of greater popular appeal, a politically motivated reaction that, in the 1930s under Stalin, gave rise to **Socialist Realism**.

Naum Gabo, *Construction in Space: Arc No. 2*, 1958/63. Silicia bronze, rust-free wire, tin on wood plinth, height 82.6 cm. Private collection, London.

Vladimir Tatlin, Model for the Monument to the Third International, 1920. Wood and metal, height 420 cm.

Alexander Rodchenko, *Circle within Circle, No. 9*, 1920–21. Peach-wood plywood, 90 x 80 x 85 cm. Galerie Gmurzynska, Cologne.

As he developed the themes of line and space in his painting, so Rodchenko decided to launch into the third dimension. The resulting constructions were an entirely new invention in the field of sculpture.

For the first time, a pedestal was dispensed with and the piece was suspended in space. Nor did it any longer have a front, side, or back view, as it continually turned to reveal first one aspect then another, while the light falling on it gave rise to constantly changing visual impressions.

VISUAL ART AND PHOTOGRAPHY

Photography was developed in the 1830s and rapidly became a source of inexpensive portraiture and landscape as well as scientific imagery for future art movements, as evidenced by **Muybridge's** 1878 series of moving animals that heralded Futurism, and Charcot's photographs of the mentally ill that influenced the Surrealists. ■ The **Pictorialists** (c. 1890–1914) imitated the aesthetics of painting in their photography, with exponents such as **Cameron, Demachy**, and **Puyo. Stieglitz**'s Photo-Secession produced more advanced compositions and experimented with materials (gum bichromate, retouching) and effects (filters, focusing), thus elevating the status of the photographer to that of an "artist/craftsman." More natural approaches were encouraged by **Atget** (who chronicled Paris), **Sander**, and **Hine**. ■ Photography entered the avant-garde through Italian Futurism with the sequential photos of **Photodynamism** as practised by the **Bragaglia** brothers; the humorous **photomontages** by **Hausmann** and **Ernst**, and the satirical ones by the anti-Nazis **Heartfield** and **Höch**; the cameraless photography of **Moholy-Nagy** and **Man Ray**; the objectivity of **Renger-Patzsch** and **Blossfeldt**; the playful imagery of **Kertész**; and the poetic atmospherics of **Brassaï** and **Peterhans**. ■ A new voice in photography in the English-speaking world came in the shape of the artistic, optical approach of **Weston** and **Adams**, the landscapes of **Brandt**, and the "straight" (i.e. unretouched, unmanipulated) documentary styles of Evans and Lange. ■ Photography also played a more straightforward role in the traditional arts. Brassaï had chronicled Picasso's studio, while Brancusi took photographs of his own sculptures and practice. During the 1940s in the US, the collaboration between photographer **Namuth** and Pollock illuminated the creation of the latter's Abstract Expressionist paintings in ways previously unthinkable. ■ In more recent times, photography has facilitated techniques of multiple production and Superrealism, as well as serving to record Happenings and Body art. Modern "photoworks" go beyond the reproduction of a pre-existent object, often using digital forms to create new images.

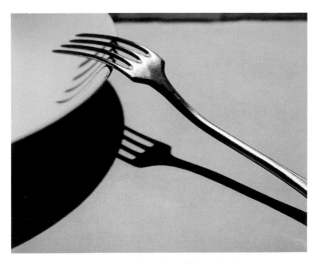

André Kertész, *The Fork*, 1928. Silver gelatin (vintage) print.
19.4 x 24 cm. Museum Ludwig, Cologne.

In the 19th century, photography's status as an art form had often
been questioned. Baudelaire called the new medium "the mortal
enemy of art" in 1859, while the daguerrotype's accuracy induced
the academic artist Paul Delaroche to fear the "death of painting."
In this work, the centering of the subject and its cropping by the
frame, as well as the textural juxtapositions, are wholly unpainterly.
The pure tones of the silver gelatin print allow the metallic quality
and plastic elegance of the fork to come through. The tiny stain on
the plate and the out-of-focus prongs are typical photographic
details.

DADA

In 1916 a group of European artists met in Zurich—painters, sculptors, and writers who called themselves Dadaists. Dada was a nonsense word, just as the art they practised was purposely nonsensical—a protest against reason and logic, a negation of aesthetic beauty. Appalled by the brutality of mechanized war, the Dadaists felt that all the values of Western civilization had been discredited. Dadaism was a revolt that derided law and order and was expressed in terms of chaos, obfuscation, chance occurrences, the grotesque, (self-) contradiction, irony, and general clowning. ∎ In addition to Zurich, Dada movements emerged almost concurrently in Paris and New York. ∎ The key protagonists were **Arp**, **Duchamp**, **Ernst**, **Picabia**, **Man Ray**, and **Schwitters**. ∎ In the beginning it was artists of the spoken and written word such as Tristan Tzara who proclaimed Dada, but soon painters attempted to bring its absurd world view into visual art. This could take the form of collages of completely unrelated visual fragments, creating arbitrary juxtapositions that experimented with chance in a way that ran counter to common sense. Yet playfulness also played a role in a celebration of the banal, expressed in appealing but nonsensical, witty, or even crazy compositions, which rejoiced in the existence of irreconcilable contradictions. ∎ Perhaps the most extreme Dadaist artist was Duchamp. He displayed a

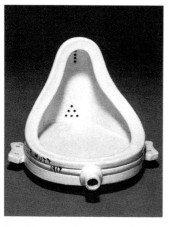

urinal, a coal shovel, and a bottle-rack at art exhibitions, and explained that such manufactured "ready-made" objects were art works because he had declared them to be such. ∎ In the long run, the approach could not satisfy, for as one artist said, Dada was "a passage, but not the destination." Some Dadaists joined Surrealism, and by the time the manifesto of the movement appeared in 1924, Dada was over.

Marcel Duchamp, *Fountain*, 1917/1964. Ready-made, 62.5 x 35.5 x 49 cm. Indiana University Art Museum, Bloomington.

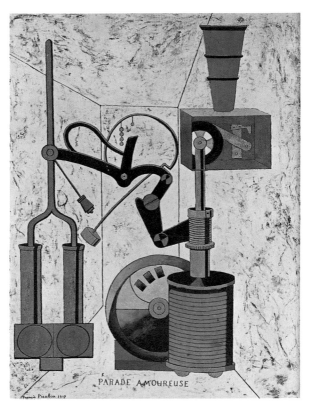

Francis Picabia, *Love Parade*, 1917. Oil on canvas, 96.5 x 73.7 cm.
Mr. and Mrs. Morton G. Neumann, Chicago.

Picabia loved wry, grotesque humor. In his *Love Parade*, the act of
love is depicted in the shape of a nonsensical mechanical con-
trivance. Its absurdity was also likely intended to puncture the mys-
tique that surrounds fine art.

(Final)

Four Dutch artists initially belonged to the De Stijl [The Style] group, which was founded in 1917: the painters **van Doesburg** and **Mondrian**, the painter and sculptor **Vantongerloo**, and the architect and designer **Rietveld**. ■ They described their main principle as a striving for total abstraction that was confined to the straight line and right angle. Their palette too was limited to the three primary colors, red, yellow, and blue, and to the three "noncolors," black, white, and gray. ■ De Stijl envisaged an art composed of the most basic elements and dispensing with anything that even remotely suggested an object. The compositions were reduced to a minimum, the painted surfaces smooth and without visible brushwork, the lines drawn with a straight-edge and always perpendicular to one another. These are images of lucid order, carefully constructed and yet full of harmony, imbued with the aesthetic of the modern age. ■ Naturally such pictures bear a family resemblance, yet the endless possible variations of squares and rectangles, thin and broad bands, color arrangements and formats, lend them individuality nevertheless. ■ From the start De Stijl artists envisaged working together with architects and designers to create an overarching project, a complex and yet unified environment in which people could lead better lives. To bring art and life together into a greater whole—that was their dream. ■ The Dutch

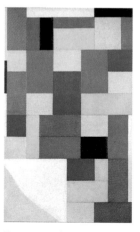

Constructivists, as the group is also known, had much in common with the Russian Constructivists. But they were even more extreme, since they admitted no curves or circles, nor even diagonals, into their paintings. ■ Mondrian was so wedded to the idea of perpendicularity that when van Doesburg employed diagonals in a composition in 1925, he left the group. Mondrian was also the only member of De Stijl who remained true to its principles to the end of his career.

Theo van Doesburg, *Composition*, 1920. Oil on canvas, 130 x 80 cm. Musée National d'Art Moderne, Centre Georges Pompidou, Paris.

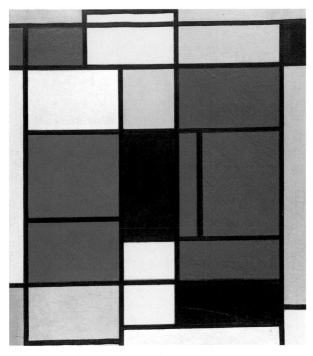

Piet Mondrian, *Tableau No. 1*, 1921–25. Oil on canvas,
75.5 x 65.5 cm. Fondation Beyeler, Riehen.

Mondrian was an advocate of absolute clarity and order. In the
course of his career he proved that this reduced style was capable
of bringing forth imagery of great visual interest and diversity.
Gradually Mondrian reached the point at which no further simplifi-
cation of the elements in the painting seemed conceivable. He
divided the surface with narrow black bands and filled in the fields
between them with primary colors.

PITTURA METAFISICA

The name of this Italian style is usually translated as Metaphysical Painting. According to Webster's Dictionary, metaphysics is "the branch of philosophy that deals with first principles and seeks to explain the nature of being or reality ..." ▪ It was in much the same terms that **de Chirico** explained the artistic approach he developed in collaboration with **Carrà** in 1917. De Chirico maintained that common sense and logical thought had no place in art. A truly profound work of art would have to be brought up by the artist from the remotest depths of his being. ▪ Pittura Metafisica was a direct reaction to Italian Futurism. Celebrations of technology and violence must come to an end, de Chirico and Carrà declared. Instead they envisaged a poetic art which would spirit viewers out of the troubled present and back to a dreamland of antiquity, to a revival of the joyous innocence of the classical Italian landscape and its towns. Yet their imagery, for all its apparent innocence, often took on a nightmarish air. Faceless mannequins, sexless figures stood motionless in silent piazzas. The houses were abandoned, their doors locked and their windows deserted. Trees, meadows, flowers were nowhere to be seen. A cold, invisible sun illuminated eerie figures and undefinable objects, casting long shadows. ▪ A novel if enigmatic reality replaced the everyday. Exaggerated perspective was used to evoke illusionary piazzas and urban spaces that metamorphosed into imaginary realms,

shot through with anxiety and an endless, numbing loneliness. Pittura Metafisica abounded with psychological symbols of an alienated, oppressively artificial world. ▪ In 1920 de Chirico suddenly became convinced of the inadequacy of his previous work and decided to change his style. The group dispersed after only three years of existence.

Carlo Carrà, *The Enchanted Room*, 1917.
Oil on canvas, 68 x 52 cm. Pinacoteca di Brera, Milan.

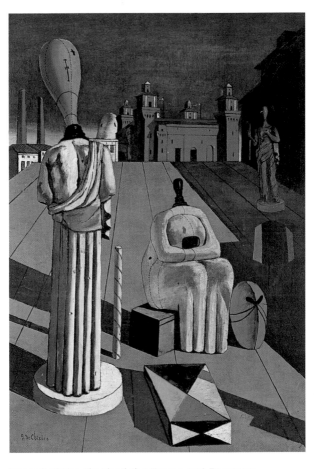

Giorgio de Chirico, *The Disquieting Muses*, c. 1916. Tempera on cardboard, 94 x 62 cm. Staatsgalerie Moderner Kunst, Munich.

"To be truly immortal, a work of art must transcend the frontiers of the human," said de Chirico of his art, from which human life seems indeed to have been expunged. All that remain are lifeless statues and headless dolls, inhabiting a world of oppressive silence.

NOVEMBERGRUPPE

The Novembergruppe, or November Group, was an association of artists established in 1918 in Germany, whose first priority was to bring modern art to ordinary people. This aim was inspired by the November Revolution in Germany, which had led to the abdication of Kaiser Wilhelm II and to a popular demand for more influence at every level of government. ▪ Artists too began to resist State regimentation of the arts and architecture. They succeeded in having a Working Council [Arbeitsrat] for Art set up, which was to have a say in all public measures relating to cultural affairs, from architecture and urban planning to art academies and museums. This initiative was supported by a great number of well-known architects, writers, composers, sculptors, and painters, such as **Baumeister**, **Dix**, **Feininger**, **Grosz**, **Heckel**, **Itten**, **Kandinsky**, **Klee**, **Meidner**, **Moholy-Nagy**, **Pechstein**, **Schmidt-Rottluff**, and **Schwitters**. Virtually the entire avant-garde of German artists and foreign artists active in Germany was involved in the group. ▪ Though they did mount a series of much acclaimed exhibitions which formed an outstanding record of the development of German art at that period, the success of their project fell short of expectations. The Novembergruppe remained active until its forcible disbanding by the Nazis in 1933.

Lyonel Feininger, *Quiet Day on the Sea III*, 1929.
Oil on canvas, 49 x 36.2 cm. Private collection,
U.S.A. Courtesy of Achim Moeller Fine Art, New York.

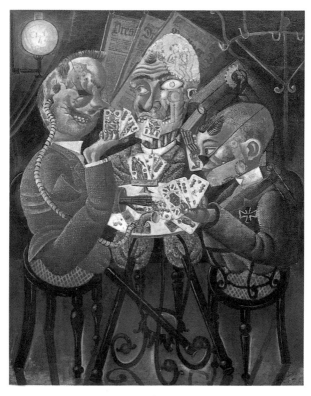

Otto Dix, *Disabled War Veterans Playing Cards*, 1920. Oil and collage on canvas, 110 x 87 cm. Private collection.

Dix painted this picture two years after the First World War. Its horrors are unforgettably evoked by the men's deformed faces and crippled hands and legs. Their glass eyes and artificial jaws and limbs are depicted with merciless precision.

Many artists of the period subjected Weimar society and its conflicts to such searching analysis. They evoked a world on the brink of the abyss.

NEW OBJECTIVITY

Most of the artists of the German movement known as New Objectivity, or Neue Sachlichkeit, began in a Cubist or Futurist style. It was their experiences in the First World War that led them to adopt an approach of extreme verisimilitude. The movement was prevalent between the two world wars, beginning in 1918 and having its first comprehensive showing in 1923, in several German cities. The major exponents of New Objectivity were **Beckmann**, **Dix**, **Grosz**, **Hofer**, **Schrimpf**, and **Schad**. ■ These artists were also known as **Verists** on account of their merciless focus on current conditions in society. They depicted an insecure post-war world haunted by memories of the horrors of the conflict, and by anxiety, suffering, despair, and famine. They evoked big-city life, from the underworld of prostitutes and pimps, gangsters and war profiteers, to the representatives of a newly prosperous bourgeoisie. It was the visual reply of socially committed artists to the post-war crisis in the Weimar Republic. ■ To represent such scenes, the artists concentrated on harsh, relentlessly crisp lines, using color mostly to symbolically underscore the pervasive mood of the picture. ■ New Objectivity was a protest and an appeal, a desperate attempt to come to terms with the current situation. Each artist did this in his own way. In the case of Dix and Grosz, accusation predominated, while Beckmann, Hofer, and Schrimpf

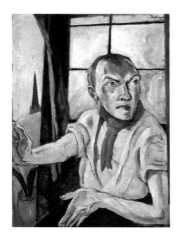

tended to be more introspective. On the one hand, reality was depicted with veritably cruel precision, yet on the other, pictures full of joy and beauty later emerged. ■ New Objectivity ended when the Nazis came to power. Many of its proponents emigrated, a few came to terms with the new regime, and several continued to work underground.

Max Beckmann, *Self-Portrait with Red Scarf*, 1917.
Oil on canvas, 80 x 60 cm. Staatsgalerie Stuttgart.

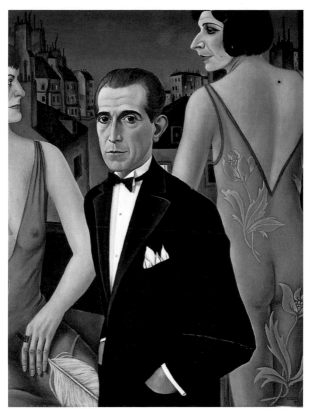

Christian Schad, *Count St. Genois d' Anneaucourt*, 1927.
Oil on panel, 86 x 63 cm. Private collection.

Portrayed to the count's left is Baroness Glaser, and to his right, a
nameless transvestite.
The eminent critic Wieland Schmied has described the realistic style
of the period as being characterized by "a sobriety and a sharpness
of vision, an unsentimental point of view largely devoid of emotion.
A focus on the everyday and banal, on insignificant and ordinary
subjects, and a lack of aversion to the ugly."

THE BAUHAUS

The Bauhaus was an art school and a college of design, that was established in Weimar in 1919, and moved to Dessau in 1925. It was founded by the architect **Walter Gropius**. ▪ The Bauhaus curriculum encompassed all practical and theoretical fields of art, craft, design, photography, and architecture. It was built around the idea that craftsmanship is the basis of every art. Even students of painting were expected to first learn a craft. The Bauhaus program envisaged a unity of all the arts, analogous to that found in the medieval guilds of building. In fact, the name Bauhaus derived from the German term for such a guild, *Bauhütte*. Gropius recruited an outstanding faculty, which included architect Ludwig Mies van der Rohe and sculptor Gerhard Marcks, but probably the greatest contribution was made by the painters on the faculty, who at the time were already widely recognized: **Albers**, **Feininger**, **Itten**, **Kandinsky**, **Klee**, **Moholy-Nagy**, and **Schlemmer**. ▪ All of them were uncompromising innovators in modern art. Their connections with the artists of the Dutch De Stijl group, the Russian Constructivists, and the Blue Rider brought further key impulses to the Bauhaus. ▪ After fourteen years of existence the school was closed by the Nazis in 1933. The artists were persecuted; many went into exile so as to continue to work and teach in their adoptive countries.

Johannes Itten, *Bird Theme*, 1918. Oil on canvas, 110 x 55 cm. Museum Moderner Kunst, Vienna.

Bauhaus Toy, 1924. Designed by Alma Siedhoff-Buscher.

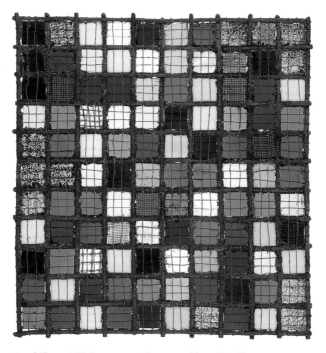

Josef Albers, *Grid Picture*, 1922. Glass assemblage. The Albers
Foundation, Inc., Orange, Connecticut.

Here is an excerpt from the prospectus of the State Bauhaus,
Weimar, published in 1919:

Instruction at the Bauhaus encompasses all practical and theoreti-
cal fields of visual creativity: a) Architecture; b) Painting; c) Sculp-
ture. Students are trained in crafts, in drawing and painting, and in
scholarship and theory...Practical instruction in the painting class
comprises experiments in all known paint media and in the devel-
opment of new techniques of employing color...In theoretical
instruction, color systems, color psychology, and color organization
are discussed.

The curriculum developed at the Bauhaus became the standard for
many subsequent German, European, and American art schools.

SOUTH AMERICAN MURALISM

A continuation of the Pre-Columbian and colonial tradition of monumental wall painting, the Muralist movement in South America (especially the so-called **Mexican Mural Renaissance**) sought to create a new "awareness of our own identity and of our destiny" (Orozco) following the Mexican revolution of 1910. In 1922, under the Minister for Education José Vasconcelos, art in Mexico became a propaganda arm of the state. Influenced by the Renaissance, Cubism, Expressionism, and traditional forms, the huge fresco or encaustic ensembles were concentrated in Mexico City and Guadalajara. The three painters most associated with the Mexican Mural Renaissance were **Rivera**, **Orozco**, and **Siqueiros**, but it also included **Leal** and **Revueltas**. ▪ Early in its development, themes were quite conventional (Rivera with the Creation, Orozco and Siqueiros with the Elements), though soon an overtly political agenda dominated. Rivera's subjects were drawn from modern and pre-Hispanic Mexican history (e.g. his murals in the National Palace, from 1929), treated decoratively yet didactically. Less politically aligned, Orozco began in a caricatural style akin to New Objectivity in his use of dark-hued, garishly lit coloring. Siqueiros was the most ideologically radical (his avowed aim being to "destroy bourgeois individualism") and harsh and dynamic in his treatment, often of Surrealistic visions and monstrous, seething figures. ▪ These artists all influenced art in the United States. Rivera lived in San Francisco, Detroit, and New York in the early 1930s. Orozco, like **Benton**, painted a series of murals for the New School for Social Research in New York. Siqueiros was also in New York in the mid-1930s where he trained Pollock. ▪ Large-scale propagandist art was also taken up in other Latin American countries: Ecuador with **Guayasamín** and Brazil with **Portinari**. The Mexican **Tamayo** appeared later and was opposed to Muralism's literalness and Expressionism, instead focusing on tackling aesthetic problems.

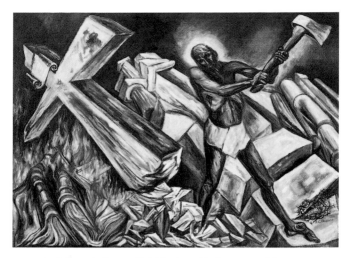

José Clemente Orozco, *Christ Destroys his Cross*, 1943. Oil on canvas, 93 x 130 cm. Museo de Arte Alvar y Carmen T. de Carillo Gil, Mexico City.

Orozco was involved in mural painting by 1922 in the National Preparatory School (formerly the Jesuit Institution of San Ildefonso). A version of *Christ Destroys his Cross* [*Cristo destruye su Cruz*] was already included, with paintings on the worker, soldier, and struggling peasant. For Dartmouth College, Hanover, New Hampshire, Orozco painted frescoes, including a *Christ Destroys his Cross* (1932–34). The present approach to the subject — one that was obviously close to the painter's heart — symbolizes the refusal of the victim to bow to his fate, a rejection of posthumous, supernatural rewards and the human nature of ethical virtue.

SURREALISM

The term Surrealism is of French origin, the prefix "sur" designating a "super" or "higher" realism. ■ It was a current in art that focussed on visually representing subconscious or dream imagery, which was depicted in a realistic manner. It began in 1924 with a loose grouping of writers and artists around the author of its Manifesto, **André Breton**. The artists included **Arp**, **de Chirico**, **Ernst**, **Magritte**, **Masson**, **Man Ray**, and **Miró**, who were joined in 1927 by **Tanguy** and in 1929 by **Dalí**. They created no unified style, for as regards intentions and ideas, inventiveness and craft, these artists were extremely diverse. ■ What they did share in common was taking inspiration from the psychoanalysis of Sigmund Freud, who discovered that thinking, feeling, and behavior are largely grounded in the unconscious mind whose forces shape our personality. This discovery provided a crucial source of the Surrealists' subject matter. They attempted to plunge into that dark realm which lies beneath the surface of daily life, and to bring its imagery to light to reveal a new reality. ■ Their paintings contained ordinary things combined with unprecedented, visionary objects, in juxtapositions that often seemed irrational, strange, and disquieting. ■ It was imagery that resisted logical explanation— eerily unreal, baffling, sometimes ironical, and often apparently absurd. Yet it was suffused with great emotion and intellectuality. The unprecedented nature of Surrealist imagery sparked the invention of new techniques, from **frottage** [rubbing] and collage to decalcomania [scraping through paint layers]. ■ The Surrealist movement was nowhere so vital as in France. Once again, Paris served as the center of an international development in art.

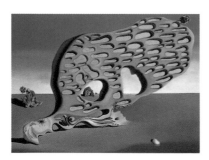

Salvador Dalí, *The Enigma of Desire*, 1929. Oil on canvas, 110 x 150 cm. Oskar Schlag Collection, Zurich.

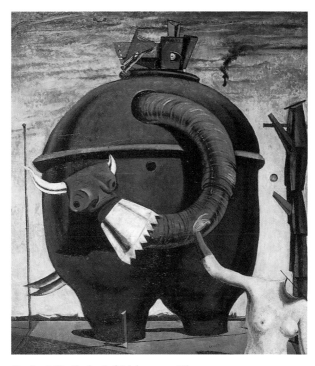

Max Ernst, *The Elephant of Celebes*, 1921. Oil on canvas,
125 x 108 cm. Tate Modern, London.

This monster has a body form derived from that of an iron grain bin,
and is fitted with all sorts of technical paraphernalia, such as a
trunk in the form of a ventilation duct that leads back into the body.
On the right a headless female figure walks out of the picture. As
one explanation puts it: "This is the blindness, anxiety, and violence
of man faced by constraint, ignorance, and death."

ABSTRACTION-CRÉATION

Abstraction-Création was an association of European and American artists founded in Paris in 1931. Their aim was to organize exhibitions of non-objective art in the hope of making it more widely known. ∎ At times the group comprised more than 400 artists, including, to name only the European ones, **Albers**, **Arp**, **Baumeister**, **Bill**, **Robert Delaunay**, **van Doesburg**, **Gabo**, **Kandinsky**, **Kupka**, **Le Corbusier**, **Léger**, **El Lissitzky**, **Moholy-Nagy**, **Mondrian**, **Ben Nicholson**, **Pevsner**, **Schwitters**, and **Vantongerloo**. ∎ As this list indicates, an immense variety of approaches were admitted. ∎ The name Abstraction-Création combined a focus on abstract or non-figurative art with a creative activity that had recourse to the entire range of visual techniques and methods, from painting and sculpture to photography, collage, and assemblage. In making a work of art virtually no material was excluded, whether glass, plastic, metal, or paper; wood, textiles, plaster, cement, or sand. This represented a significant extension of the types of media available to artists. Thanks to their annual exhibitions and newsletters, the members of Abstraction-Création achieved worldwide recognition. ∎ The imaginative free spirit which so characterized the art of this period was brought violently down to earth by Nazism in Germany and the ensuing World War. After six years of existence the international artists' association Abstraction-Création was dissolved in 1936.

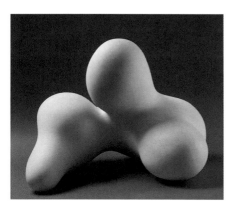

Hans Arp, *Human Concretion*, 1934. Plaster, 35 x 42 x 34 cm. Private collection, France.

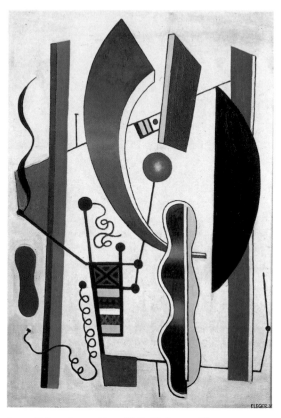

Fernand Léger, *Composition with Red Ball*, 1934. Oil on canvas, 130 x 88 cm. Collection of M. and Mme. Adrien Maeght.

For all their differences in style and personality, the members of Abstraction-Création shared in common a commitment to abstract art. This was reflected in the title of their illustrated annual publication, *Abstraction-Création, Art non-figuratif*.

Léger's picture provides a good illustration of their intentions. It is built of planes, lines, and shapes derived from the virtually inexhaustible repertoire of geometry, arranged on the canvas and solidly linked by a linear scaffolding.

AMERICAN SCENE PAINTING

American Scene Painting (c. 1931–42) describes a realist style of painting in the United States, which was particularly prevalent during the Great Depression. A government-sponsored reaction against the European styles that had surfaced following the New York Armory Show in 1913, it was an attempt to define a uniquely American aesthetic that combated Cubism, abstraction, and even Art Deco. It is loosely divided into two main schools: urban and politically-oriented Social Realism, and rural **Regionalism**, although the evocative **Hopper** and the fantastical **Burchfield** fall into neither camp. Both style and subject had to be "American," one official stating that "foreign subject matter had better be dropped." American Scene was fostered by many of the government sponsored organizations promoting art in the 1930s, such as in the 1,100 murals created for public buildings, mostly post offices. ■ American Social Realism promoted positive, democratic ideals through mass-appeal subject-matter in murals (a crucial influence being South American Muralism) and prints, as well as easel work. As part of his preparation, the artist was often expected to live closely with the community he depicted. Significant Realist artists included **Biddle**, **Levine**, **Arnautoff**, **Shahn**, and **Fogel**. ■ Regionalism refers to the work of a group of mainly Midwest rural artists whose liberal/rightist populism was in fact at odds with the urban left-wing Social Realists of the same era. The three best known were **Benton**, **Curry**, and **Grant Wood**. An influential teacher at the Art Students League, Benton's orientation was away from the big cities, focusing instead on the expanding villages, which for him epitomized the old frontiersmen of "true America" (as in his *America Today* mural). ■ The Second World War forced Americans to turn to international issues. The renewed contact with European art through immigration and the individualism that came in the wake of the ideological disasters of the conflict, and of the Cold War, practically eliminated the "National" style of American Scene Painting.

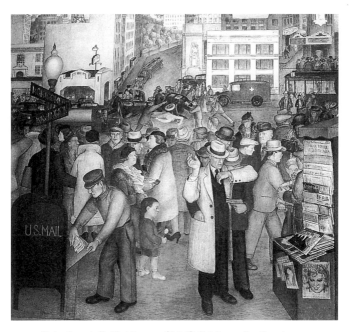

Victor Arnautoff, *City Life*, 1934 (detail). Coit Tower, San Francisco.

Ukrainian-born Arnautoff worked under Diego Rivera and for the Works Progress Administration, a government-sponsored organization designed to produce socially meaningful public art.

This work shows some resemblances to the work of the November-gruppe and New Objectivity in the caustic detail of the hold-up in the foreground. The style is more conservative, however, and the treatment of the figures more respectful.

Arnautoff returned to the Soviet Union in the 1960s where he continued to work as a painter.

ART UNDER THE DICTATORS
STATE AND PARTY

Though ideologically at odds, the art of the two main dictatorships of the 20th century—the Soviet Union and Nazi Germany—possessed a number of common features. Both favored monumental, often triumphalist or oppressive imagery, and both were eclectic in their aesthetics, fusing expressions of power with a nostalgia for an ideal classicizing past; and the Nazis tended to be even more conservative than the Soviets. ▪ **Socialist Realism**, which appeared in the Soviet Union in 1932, was the official art of the Communist Party. The State instructed artists to produce an ideological culture fit for the people. Themes included the world of work (**Plastov, Gerasimov**) and industry (**Popkov**), portraits of the great leaders (**Brodsky**) and heroes (**Merkurov, Mukhina**), and historical scenes (**Deineka**). The art was neither strictly realistic nor part of historical **Realism**, instead depicting easily understood dramas with kitsch and bombast. Most of the art of the time had few purely aesthetic goals. A similar style was adopted throughout the Soviet Blok and with fierce conservatism in Maoist China. ▪ In the twelve-year rule of the Nazis (1933–1945), **National Socialist art** was viewed as a tool of the German Reich. It radically opposed German modernism such as Die Brücke, and was reactionary, cliché-ridden, and pseudo-classical. Organized by the State, the main themes were work, family, and landscape, as well as the "New Nordico-Germanic Superman," as in **Breker's** sculptures. Most paintings were produced by run-of-the-mill artists who adhered to strict state guidelines. A critic of the time wrote: "A new type of German artist has emerged who is a far cry from the degenerate Bohemians and Salon aesthetes of the 'decadent period.'" The 1937 exhibition of this "art of the people" [Volk] was invaded by heroic battle scenes and saccharin idylls. ▪ In Fascist Italy a somewhat similar art sprung up, though Mussolini initially succeeded in convincing artists of note to join his efforts to forge a Fascist culture, such as **Sironi, Campigli,** and **Carrà**.

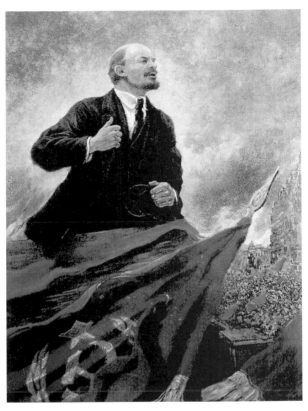

Alexander Gerasimov, *Lenin at the Tribune*, 1930. Central Lenin Museum, Moscow.

Art in Stalin's Soviet Union was prescriptive: any artist who failed to toe the State line either had to flee abroad or go underground. The others simply painted whatever Stalin liked: Revolutionary history, battles of the Civil War, portraits of heroes, and paragon Soviets. This idealized representation of Lenin by Gerasimov is a prime example of the style in its dramatic allusion to famous photographs of the great leader and its microscopic treatment of the inspired masses behind.

Art Against the Dictators
Persecution and Unofficial Art

Under the Nazis, the German international avant-garde movement was brought to an abrupt halt. The suspicion was that such art represented both a danger to and a criticism of the regime, whereas the propaganda preferred by the Nazi elite was entirely under Party control. 1933 saw the beginnings of a systematic persecution of independent artists, with bans on exhibitions and even production; in 1935 came the removal of their works from State galleries. The 1937 touring exhibition *entartete Kunst* [degenerate art] juxtaposed the art of the moderns with the "worthless" products of the "insane" and of "primitive" peoples. Well-known artists such as **Baumeister, Dix, Heckel, Hofer, Nolde, Pechstein, Rohlfs, Schlemmer,** and **Schmidt-Rottluff** when they remained in Germany went underground and ceased significant work; others, such as **Albers, Beckmann, Feininger, Grosz, Hartung, Kandinsky, Klee, Kokoschka,** and **Schwitters** fled abroad. ■ In Italy, where there was a measure of latitude, **Guttoso** and the **Corrente** group bravely opposed Fascism, while compromised artists were able to return to less stereotyped work after the fall of the regime. In Spain the political situation had been heralded by Picasso's famous *Guernica* (1937), depicting the destruction of the town by Franco's bombers: only in the 1960s did the artists' position become easier. ■ Unofficial art in the Soviet Union was severely curtailed under Stalin, with many artists suppressed and even exiled to the gulags. Following Khrushchev's criticism of Stalin's abuses of power in 1956, a barely tolerated avant-garde art emerged which followed Western developments. The most original art form from the late 1970s to the Gorbachev era (1985–91) was Sots Art, an ironical reworking of **Socialist Realism,** with **Komar and Melamid** being the most striking representatives.

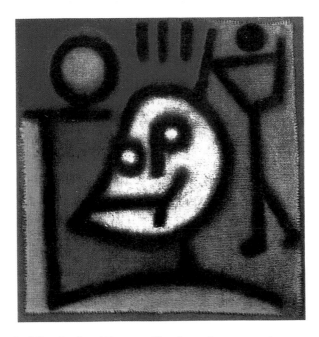

Paul Klee, *Death and Fire*, 1940. Oil and gouache on a gouache ground on jute, 46 x 44 cm. Kunstmuseum Bern, Paul Klee Foundation.

Klee produced this picture the year he died. He had painted and taught for years in Germany, but had been forced to abandon all his posts in 1933 after the imposition of a working and teaching ban. He fled to Switzerland. The painting depicts immediate reality translated into pictorial signs. Showing an agonized human face on a stark, red ground, it can be read as expressing the suffering of war and persecution.

War, famine, homelessness, and persecution had brought Europe to its knees. All over the continent, staying alive and acquiring the bare necessities had long been the population's main concern. For a variety of reasons, throughout Europe the whole social fabric had been destroyed: Germany was divided into four Allied zones of occupation; Austria was a pariah state; France and Italy were racked with recriminations and reprisals; and even victorious Britain was in economic ruin and soon lost her Empire. Only America seemed capable of putting democratic civilization back on its feet. Nonetheless, art was probably the last thing the disillusioned population of Europe craved. ■ Many major artists were dead or living in exile, often in America. Among the latter numbered **Ernst** (who twice escaped internment), **Masson**, **Dalí**, and **Tanguy**, who all joined the Surrealist leader, **André Breton**; **Mondrian**, who came from London in 1940 after a bomb hit his studio, and responded to New York life with his *Broadway Boogie-Woogie*; while the Purist **Ozenfant** too transferred his studio to New York. ■ Some German artists—**Albers**, **Beckmann**, **Hartung**, **Kokoschka**, and **Wols**—had fled from Nazism and were active abroad. These artists rapidly carved out a place for themselves in the new art scene. ■ After 1945, Europe at last became cognizant of art in the United States. Great talents had emerged during the pre-war and war years, and their works now crossed the Atlantic where they had a deep and lasting impact. The most significant were **Gorky**, **de Kooning**, **Motherwell**, **Newman**, **Pollock**, **Rothko**, and **Tobey**. ■ Out of this diversity of personalities and approaches arose a fascinating and vivid kaleidoscope that introduced a new era in art in the free Western world. ■ Back in Europe, the artists who had stayed on in Nazi Germany had most-

ly passed the peak of their powers, though painters who had struggled to work during the years of persecution (e.g. **Baumeister,Dix**, and **Nay**) could now re-emerge into a public arena. ■ In France, war and the German occupation had not seriously hampered developments in art, though many had fled a detested regime. Great painters like **Braque**, **Léger** (who also traveled to the United States in the late 1930s), **Matisse**, and **Picasso** continued working unabated. A younger generation now came to the fore, such as **Fautrier**, **Soulages**, and **Vasarely**, who were soon to put France firmly on the abstractionist map. ■ Like Germany, Italy suffered under Fascist tyranny, but after 1945 scores of young artists came under the sway of formerly banished abstraction. Nourished by the fruitful ideas of the historical avant garde of the pre-Mussolini period, these included **Birolli**, **Magnelli**, and **Vedova**. ■ These three European nations, which until now had played the leading role in modern painting, were joined in 1945 by Britain. Although many contemporary English painters enjoyed an international reputation, they had yet to make their mark on the Continent. The best known were the painters **Bacon** and **Sutherland**, the relief artist and painter **Ben Nicholson**, and the sculptor **Henry Moore**. ■ In the Eastern European countries and the USSR, by contrast, there existed only a State-approved stereotyped art, which toed the party line and promised little hope of development. Artists in these countries were prohibited from making contact with their contemporaries beyond the Iron Curtain. The departure into a new era took place without them.

ABSTRACT EXPRESSIONISM
THE UNITED STATES

Abstract Expressionism can be described as an art in which the act of painting itself takes precedence over content or subject matter. ■ For the first time in the history of modern art, the United States was the point of departure for a significant development. The groundwork was laid in 1936 when American artists formed a group known as American Abstract Artists or AAA. When the war ended in 1945, Abstract Expressionism emerged on the scene, marking the beginning of a new era in painting. New York henceforth was to supplant Paris as the center of world art. ■ Abstract Expressionism was not a precisely defined style. It encompassed virtually every possibility open to artistic expression, with the exception of strict realism. It was an approach that took its cues from previous styles such as Surrealism with its reliance on subconscious or dream imagery, Orphism with its reveling in color, or Dada with its emphasis on chance. To these influences artists added the spontaneous gesture of the hand. The canvas became an arena of uninhibited action in which any and every means of applying paint was used—brushing, pouring, throwing, dripping. Artists gave their emotions free rein in the act of painting, resulting in works which combined chance, improvisation, and a record of mental states with form, color, and sumptuously painted surfaces.

■ The great stream of Abstract Expressionism flowed into three key tributaries. The first, expressive Lyrical Abstraction, was represented essentially by **Pollock**, who used an unprecedented technique to produce paintings of unusual power, pouring lacquer direct from the can or spattering it with the brush—the method known as **drip painting**. The second current, where the paint was applied traditionally though in an instinctive and emotionally profound way, was represented by **Gorky**, **Kline**, **de Kooning**, and **Motherwell**. The third, Color Field Painting, was pioneered by **Newman** and **Rothko**.

Jackson Pollock, *Number 2*, 1950. Oil, lacquer, silver paint, and pebbles on canvas, 287 x 91.5 cm. Fogg Art Museum, Harvard University Art Museums, Cambridge, Massachusetts.

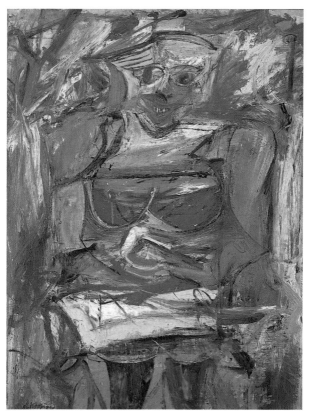

Willem de Kooning, *Woman V*, 1952–53. Oil on canvas, 155 x 115 cm.
National Gallery of Australia, Canberra.

This is a canvas from de Kooning's series of *Woman* paintings. For
all its expressiveness of attack, the figure remains recognizable,
which scandalized the exponents of pure abstraction among
the artist's friends. The violent gestural brushwork verges on the
chaotic, indicating, as de Kooning himself recalled, the effort and
desperation with which he worked on the composition.
In terms of sheer expressive power, de Kooning's paintings perhaps
remained unmatched by any other Abstract Expressionist artist in
America.

ABSTRACT EXPRESSIONISM
EUROPE

In 1945, Paris once again became the focus of an artistic movement which, though it had originated in America, was enthusiastically adopted by European artists. ■ The protagonists of Abstract Expressionism were a large group of artists who convened in the École de Paris and began exhibiting jointly in 1945. Abstract art thus established firm foundations in Europe. ■ The range of this new current of Abstract Expressionism was broad and many-faceted. Some of its variants and crosscurrents included Lyrical Abstraction, Chromatic Abstraction, Absolute Painting, Concrete painting, **L'Art Informel**, Tachisme, **Action Painting**, **drip painting**, Color Field Painting, and **Matter Painting**. ■ The keystone of Abstract Expressionist art was the sole reliance of painters on their own emotions and spontaneous inner promptings. Though elements from previous styles were present initially, soon everything reminiscent of the past vanished as Abstract Expressionism became an autonomous style of absolute independence and individual freedom. The frontiers were also rolled back as regards techniques and materials: the artists used anything and everything that could serve to convey their ideas. ■ Of the numerous artists of the École de Paris, mention should be made of **Roger Bissière**, **Jean Fautrier**, **Alfred Manessier**, **Georges Mathieu**, **Serge Poliakoff**, **Pierre Soulages**, **Nicolas de Staël**, and **Maria Elena Vieira da Silva**.

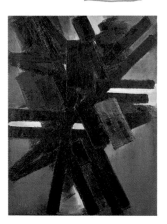

■ From Italy came **Alberto Burri**, **Lucio Fontana**, and **Emilio Vedova**, from Spain **Antonio Saura** and **Antoni Tàpies**. ■ In Germany, major artists included **Hartung**, **Wols**, **Baumeister**, and other members of the Zen group (founded in 1949), and **Götz** and **Schumacher**, both members of Quadriga (established 1952).

Pierre Soulages, *Painting: 9 June 1954*. Oil on canvas, 100 x 73 cm. Städtische Kunsthalle, Mannheim.

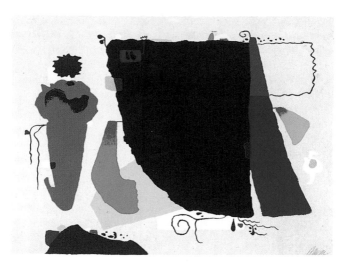

Willi Baumeister, *Phantom II*, 1951. Artist's proof silkscreen-print,
64.7 x 75.5 cm. Galerie der Stadt Stuttgart.

The title alone shows the interest Baumeister had in the "Unknown
in Art." His researches resulted in a complete book on the subject.
Nothing is recognizable at first glance in the painting. It is filled with
abstract marks and forms of poetic expressionism. Such art is inves-
ted with great beauty that spurs the viewer to deeper discoveries.

ABSTRACT EXPRESSIONISM SCULPTURE

In the post-war period, sculpture assumed an importance it had not achieved for decades. Among its major practitioners were **Armitage, Calder, Chillida, Giacometti, Marini, Henry Moore, Richier,** and **Wotruba**. ■ A continual development of new technical and craft methods led to profound changes in the art of sculpture. Artists now began to adopt industrial methods such as welding and soldering, forging and riveting, milling and sanding with power tools. They also began to use previously unheard-of materials such as hardened lava, gnarled tree branches and roots, molten lead and scrap metal, which were sometimes hydraulically pressed. Iron, steel, aluminum, concrete, artificial stone, fiberglass, plexiglass, synthetic resin, cardboard, and plywood extended the roster of new materials employed. This interest in contemporary materials and exploitation of their potential is a salient trait of sculpture after 1945.

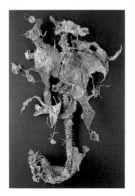

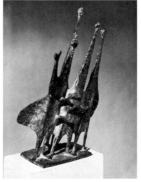

Bernard Schultze, *Long Red Migof*, 1971. Wood, oil, wire, textiles, plastic mass, 183 x 114 x 59 cm. Museum Ostdeutsche Galerie, Regensburg.

Kenneth Armitage, *People in a Wind*, 1950. Bronze, 65 x 40 x 35 cm. Städtische Kunsthalle, Mannheim.

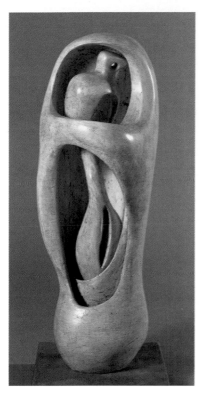

Henry Moore, *Working Model for Upright Internal/External Form*, 1951. Plaster, surface tinted, height 62 cm. The Henry Moore Foundation.

New forms were being invented in sculpture where th
figurative or non-figurative no longer pl
in Moore's approach to sculpture was t
volumes by means of hollows, apertures
rior articulation. In the present case this
contained within a figure.
Abstract Expressionism was a violent exp
tions continued to be felt right through t
century.

ART BRUT

Some art has always been produced by untutored individuals who have never been to art school. Children begin to paint at an early age; **naive** or Sunday painters (the most famous being the "Douanier" **Rousseau**) depict simplistic scenes of village life or portraits of their family; while spiritualist mediums (often women) draw bizarre shapes that represent their "visions." The most radical art of this kind, however, is that of the mentally ill (often schizophrenics), whose work ranges from the perverse, through the rigorously symmetrical (such as the huge compositions of **Lesage**), to the figurative-decorative (**Wölfli**). "Outsider Art" had been published sympathetically as early as 1922 by the Heidelberg collector-psychiatrist Dr. Heinrich Prinzhorn, but before the French painter **Dubuffet** started collecting what he dubbed "Art Brut" in 1945, it had been denied a place in art proper. ■ Art Brut translates literally as "crude art" or "raw art." Dubuffet called this art *brut* because it was influenced by uncultured art well as by "primitive" cultures. Greatly influenced by the freedom and improvised materials of such works, Dubuffet himself covered canvases with glue, sand, resin, and other substances. He then painted or scratched figures, symbols, and signs into the rough surface, resulting in crude, awkward, seemingly unsystematic, and even chaotic imagery. The unprecedented painting technique and approach appeared to most viewers to be "not normal," to which Dubuffet countered, "What is normal?…There is no more an 'art of the insane' than there is an art of […] people with knee complaints." The compelling expressiveness of Dubuffet's pictures exerted an influence on other art tendencies, such as Cobra and Tachisme.

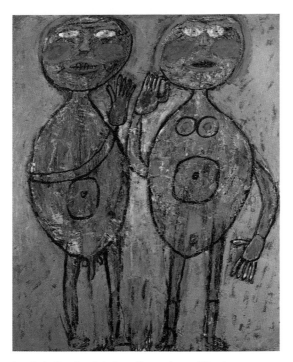

Jean Dubuffet, *Couple in Gray, Ultramarine, and Carmine*, 1945.
Oil on canvas, 100 x 80 cm. Private collection, Switzerland.

Dubuffet liberated his art totally from artistic and intellectual values, and
started painting works like a child or a primitive, who knows nothing of cul-
ture or the art world. His painting was thus intended to lie "outside" the
sphere of art, and he called it *brut* [raw].

In 1945, he made the following comment on his own art: "Random blobs,
clumsy mistakes, forms that are obviously wrong and go against reality, col-
ors that clash and don't go together. Everything that must be unbearable for
many, and which even irritate me sometimes, as they often destroy the
effect. Nevertheless I accept then as one can recognize the immediacy of
the hand of the painter in the image, and because the object is not allowed
to dominate nor things take on an overly precise form."

TACHISME

Tachisme was a stylistic variant of Abstract Expressionism. Its French name derived from a description of the painting technique used, in which *la tache*, a spot or blotch of color, played a key role. Dabs and flecks of paint were applied to the canvas without use of a predetermined composition or preliminary drawing. ▪ This spontaneous painting process enabled artists to record directly their personal sensations and feelings. The canvas became a sort of arena in which they acted out emotions, moods, and ideas. The authenticity of the traces of this process became the sole valid standard of aesthetic judgment. It was up to artists alone to decide which earlier aesthetic yardsticks if any remained valid for them. ▪ Admittedly, the lack of obvious content in these paintings proved a barrier to understanding, since viewers were challenged to abandon perceptual habits and imaginatively enter the artist's world. ▪ The first artist to work in this way was **Wols**, who showed his unprecedented paintings at the Galerie Drouin show in 1945, at the age of thirty-two. ▪ **Mathieu**, himself a Tachiste, described this show as follows: "Forty masterpieces, each more shattering, disturbing, sanguine than the next. An event, doubtless the most important since the works of van Gogh. Wols has destroyed everything. After Wols, everything will have to be done anew. At the first attempt Wols has used the idiom of our times in a brilliant, unassailable, incontestable way, and has brought it to the highest intensity." ▪ Tachisme was employed as a means of expression by many and diverse artists, from **Fautrier** and Mathieu in France to **Baumeister**, **Götz**, **Nay**, and **Schumacher** in Germany.

Georges Mathieu, *Parnes*, 1965. Oil on canvas, 100 x 197 cm. Städtische Kunsthalle, Mannheim.

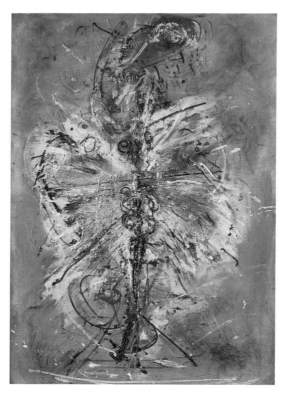

Wols, *L' Oiseau*, 1949. Oil on canvas, 92 x 65.5 cm.
D. and J. de Menil Collection, Houston, Texas.

"He inundates anything suggestive of a figure with gray streams, brooks, and runs of turpentine, letting them dissolve and eat away at everything solid and contoured. Structures become visible. Following these traces, he builds up relations, pulls them together, invigorates, emphasizes, and removes them by means of sprays of color, commas, dots, lines, abrupt, or sweeping brush gestures for which there are no formal or psychological bases. They nest in unexpected places, knot and congeal into figurations, signs, the presence of previously unseen phenomena, and surprising, inexplicable meanings." Friedrich Bayl.

COBRA AND OTHER POST-WAR TENDENCIES

After the horrors of the Second World War—the responsibility of a nation shackled to ideology—organized art groups, the notion of prescriptive art, and any hankerings after the neo-classical were totally rejected. Individualism (Abstract Expressionism), the art of the "disorganized" (Art Brut) and the freely imaginative took center stage. Although gestural abstractionism became the dominant form, figurative-influenced Expressionism was not totally abandoned. ■ In 1948, a group of painters in Paris formed **Cobra**, so named from the capital cities of the countries of three of the main artists involved (*Co*penhagen, *Br*ussels, *A*msterdam). The Dutchman **Appel**, the Belgian **Corneille**, and the Dane **Jorn** were subsequently joined by **Alechinsky** and **Constant**. Their art was based on an expressive approach to a highly abbreviated figurative imagery. Though their spontaneous, even savage, manner of applying color was similar to **Action Painting**, their bizarre iconography alluded to mystical folklore and imaginary worlds in an attempt to return to less sophisticated, perhaps "purer" origins. Short-lived, the group disbanded in 1951, though its members continued to produce work in the same vein, if often with increasing leanings towards pure abstraction. Other painters influenced by unschooled art and the rediscovery of materials but who did not embrace Abstract Expressionism as such included **Tàpies**, whose painting could incorporate rags and clay; the painter-sculptor **Fautrier**, whose *Hostages* reflected the horrors of war; and **Burri**, whose richly hued abstracts were sometimes painted on sackcloth.

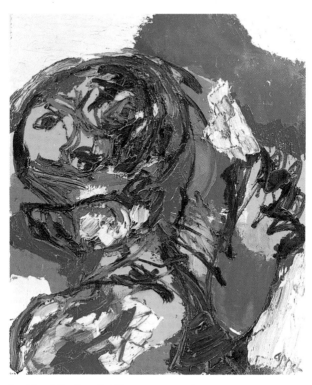

Karel Appel, *Heads*, 1965. Oil on canvas, 100 x 81 cm.
Ludwig Museum at the Deutschherrenhaus, Koblenz;
on loan from the Ludwig Collection, Aachen.

Appel's palette consisted almost exclusively of pure, unmixed
colors. He once described the process of painting as a "tactile, sen-
suous experience" and added, "my paint-tube is like a rocket that
projects its own space." His style, like that of all the Cobra painters,
was a blunt and immediate version of gestural Expressionism.

COLOR FIELD PAINTING

Color Field Painting designates a stylistic trend within Abstract Expressionism which was first expounded by American artists. Although expansive fields of monochrome color had already been used in 1915 by Malevich, thirty-five years had to pass before this approach was rediscovered in 1950 by **Newman** and **Rothko** and adopted on a wider basis. ■ Color Field works have no direct link with the outside world, contain no motifs that might serve to establish contact between artist and viewer, and their execution appears unengaged and emotionless, factors which tended to render them inaccessible to most viewers. ■ On the other hand, the paintings exude a tranquillity that is conducive to contemplation, even meditation. Composed of large, monochrome fields whose edges dissolve and merge without sharp transition into the adjacent color areas, many of Rothko's paintings possess a mystical, religious air. ■ Newman's color fields seem virtually to continue beyond the confines of the canvas to permeate the surrounding space. The monochrome fields are interrupted by bands of various widths and contrasting hues that intersect with the surface vertically or horizontally with geometrical severity. The surfaces are rendered evenly without apparent brushstrokes. Newman's work had a great influence on other artists such as **Kelly**, **Noland**, and **Frank Stella**. ■ Conforming to an approach at once disciplined and intellectual, Color Field canvases are tightly organized and based on a small number of elements. Within the vast arena of post-war abstraction, Color Field represented yet another possibility for aesthetic expression. A particular variant, with precisely severe contours and unmodulated colors, is known as Hard Edge.

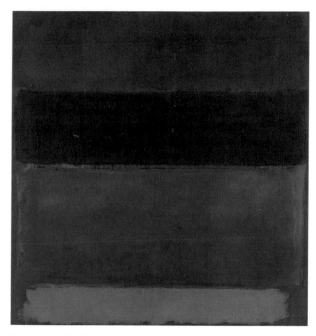

Mark Rothko, *Red-Brown, Black, Green, Red*, 1962.
Öl auf Leinwand, 206 x 193,5 cm, Fondation Beyeler, Riehen.

Mark Rothko's paintings are all unusually large in size. As he once explained, painting small pictures implies one extracts oneself from the experience. When one paints a large picture, one is actually within it. When we move up closely to these canvases, we have the feeling of being engulfed in color. The blurred, seemingly hovering planes convey a sense of great depth. The color fields metamorphose into color spaces.

Of all Abstract Expressionist works, those of the Color Field painters are the most abstract. Every trace of objective reference has been expunged from them.

FANTASTIC REALISM

Myth and the visionary world have always attracted both visual and literary artists. In the 1950s, with the continuing vogue for fantastic literature and perhaps as an escape from the polarized politics of the Cold War, many artists turned to themes of the bizarre and the marvelous. The style chosen was often precise, almost photographic, though some preferred a semi-abstract approach. ■ **Bellmer** (whose œuvre had begun in 1936 with a disjointed Doll) and **Wunderlich** were concerned with perverse sexuality. **Schröder-Sonnenstern** and **Svanberg** were painters of animal-human hybrids, while fantastic art also welcomed a long roll-call of women artists: **Fini**, primarily concerned with adolescent sexuality; **Tanning**, whose work became less figurative but remained highly erotic in the mid-1950s, and **Zürn**, who released unbearable nervous tension in automatic drawings. ■ **Oelze** and **Sutherland** were different in outlook, creating dream-like, almost semi-abstract landscapes. **Toyen's** Surrealism was purer especially in her collages, while **Wróblewski** specialized in monumental "war scenes." ■ Fantastic Realism as a school was particularly notable in Vienna (the **Wiener Schule**), which coalesced around 1950, including **Hausner**, **Brauer**, the erotico-religious etchings of **Fuchs**, and **Hundertwasser's** face/landscapes influenced by Klimt.

Arik Brauer, *Burning Woman as Flower*, 1966. Oil on plywood, 63 x 70 cm. Essl Collection, Klosterneuburg, Vienna.

Friedensreich Hundertwasser, *477 The Three Nose Rivers*, 1961. Acrylic and mixed media on paper laminated on canvas, 46 x 53 cm. Essl Collection, Klosterneuburg, Vienna.

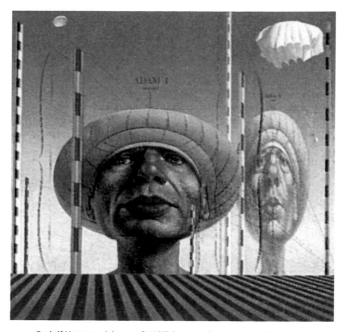

Rudolf Hausner, *Adam maßstäblich I*, 1972. Tempera, acrylic, and resin oil pigments on paper on Novopan plate, 65 x 67 cm.

This is one of many *Adam* pictures by Hausner. Over the decades in endless variations, they became the main theme of his œuvre. The creative quality of his works lies in their imaginative imagery, in his Old Master manner of painting, and in his own, unmistakeable use of colors.

HARD-EDGE PAINTING AND SHAPED CANVAS

Hard-Edge Painting describes the non-gestural, all-over works featuring large areas of color with clear-cut contours, produced by American painters working in the late 1950s to early 1960s. These included **Kelly, Al Held, Youngerman, Frank Stella, Noland, Leon Polk Smith, Liberman,** and **Agnes Martin.** In spite of a certain resemblance, Hard Edge in general was less dogmatic in its approach to color than, say, the geometrical work of Mondrian or Max Bill. Reinhardt's and Newman's use of large areas of vibrant but modulated paint are allied to Hard Edge, but their stress on grandeur of expression is quite different. The colorful cutouts by Matisse had similar crisp lines, while American precursors included work by Cubist Stuart Davis during the late 1930 and 1940s. ■ As in the work of the Color Field painters, Hard-Edge abstraction marked the moment in American art when **gesturalism** was replaced by the laying of saturated color. ■ Though non-rectangular canvas shapes such as the circle [tondo] and diamond had appeared in earlier Western art, painting had generally stuck to oblong or square formats in the wake of planar perspective. The **shaped canvas** was originated by Kelly and by Frank Stella in his "notched paintings." In **Johns'** painting of a *Flag* (1954–55), the pattern and the ground on which it rests become one. The motif is recognizable as a flag, however, and thus still possesses "meaning." Stella, on the other hand, produced wholly abstract L-, T-, and H-shaped work, in which the figure (often merely straight lines) mirrors the form of the canvas. The important relationship is now between support and motif and not between the motifs or between motif and ground. In the 1960s, the diamond paintings by Noland and **Bolotowsky,** works by **Richard Smith, Hinman, Feeley,** and **Ron Davis,** and **Murray's** multiple-layered shapeds, continued Stella's experiments. In the late 1990s, **Ed Ruscha** produced a vibrant series of canvas landscapes on bowed stretchers. The shaped canvas draws attention to the canvas as form against the background of the gallery wall, and not as a vulnerable, woven material in the manner of **Fontana's** slashed or pierced works of the late 1950s, or **Ryman's** and **Gilliam's** unstretched "suspended paintings" of the late 1960s to 1970s.

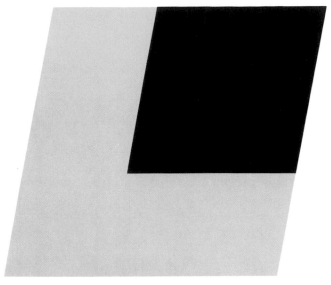

Ellsworth Kelly, *Yellow Black*, 1968. Oil on canvas,
235 x 237.5 cm. Louisiana Museum of Modern Art, Humblebaek.

The all-over motif does not emphasize center over edge, but draws
attention to the dividing line between color planes: hence color and
motif coalesce. The purely abstract forms conform to the overall
shape of the support. "What you see is what you see," as Frank
Stella memorably put it.

NEW REALISM

Abstract Expressionism drew sustenance from the inward workings of the artist's psyche. Hence it was not realistic in the sense of reflecting the outside world, and the public often found it difficult to understand. ▪ The artists of New Realism set out to rebuild the link between art and life. Beginning in 1955 almost concurrently in the United States and Europe—where its focus was in France (Nouveau Réalisme)—the tendency represented a conscious reaction against the predominance of abstract art. Two of the key techniques adopted were collage and montage, in which concrete objects were incorporated into paintings. This combination process gave rise, in America, to the term **combine painting**, and in France to its parallel, **assemblage**. ▪ The term "realism" is applied to the presence of real objects in the works. In the case of **Rauschenberg** and **Johns**, these were manufactured goods and various old, discarded things, while **Klein** at one point employed sponges soaked in blue paint and attached to monochrome blue panels. **Spoerri** glued the remnants of a breakfast to the table top, poured transparent resin over it, and exhibited the result as an art work. Such combinations of existing objects with painting far transcended the traditional borderlines of art. ▪ A unique, new visual world emerged that proved so intriguing to audiences that artists were encouraged to take the next logical step—to include the viewer in the process of making. Thus there emerged the

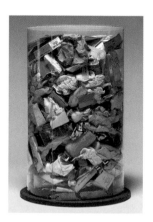

semi-staged events known as Happenings and **Performances**, in which audience participation often played a key role. ▪ As a tendency, New Realism was brief in duration, lasting only from about 1955 to 1960. In America, however, it led without transition to Pop art. The significance of New Realism can be said to lie in its having supplanted Abstract Expressionism.

Fernandez Arman, *Jim Dine's Garbage Can*, 1961.
Objects and plexiglass, 51 x 30 x 30 cm. Sonnabend Collection.

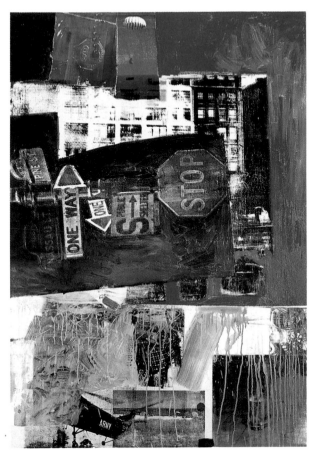

Robert Rauschenberg, *Spot*, 1963. Silkscreen and oil on canvas, 149 x 103 cm. Staatsgalerie, Stuttgart.

The artist has included a series of unpromising printed images in this large-format composition.

Using the silkscreen technique, various photographs were transferred to canvas and these fragmentary, realistic motifs combined with abstract painted areas. The compositional unity characteristic of traditional art has been abandoned in favor of a plethora of separate and disparate details to which the viewer's eye must continually readjust.

HAPPENINGS

"Happening" is a kind of **Performance art**, alongside **Action art** and the creations of the **Fluxus** group. It referred to a novel, frequently shocking artistic event that was usually relatively improvised and whose outcome was unpredictable. The process itself was considered a work of art. ▪ Often combining elements from painting, sculpture, theater, music, and dance, Happenings were intended to draw attention to artists' ideas and to encourage spectators to abandon their conventionally passive role and participate in the making of art. Happening artists thus left the studio and entered the public arena. ▪ The beginnings of the movement were associated with Pop art in America. The first Happening was organized by **Kaprow** in 1958, in New York. Artists and spectators rolled empty barrels back and forth and carried pieces of aluminum foil from one place to another. The idea was to jolt people out of their habitual perceptions and encourage participation. ▪ Happenings and their variants never reached a wide audience, because they involved only a limited number of participants and were by definition unique and unrepeatable. Nor were they capable of being traded on the art market—another reason why the movement was short-lived. ▪ Still, Happenings were enthusiastically received and reviewed, probably due to the famous artists who organized and performed in them, including **Beuys**, **Dine**, Kaprow, **Klein**, **Oldenburg**, **Rauschenberg**, and **Vostell**. Nowadays Happenings tend to be limited to Performances held in exhibition spaces in galleries or museums.

Allan Kaprow, *Southampton Parade*, 1966. Part of a collective Happening titled *GAS*, Long Island, New York.

GAS was a Happening that took place simultaneously at various places in the United States in 1966. Kaprow invited people to a park, where several familiar things were provided, in this case steel barrels and gas-filled balloons. In the course of the event, the participants shifted these objects from place to place to form continually changing visual configurations.

POP ART

This tendency began to emerge in 1955 in America and England concurrently, culminating between 1960 and 1965. Partly a reaction to the high-flown rhetoric surrounding Abstract Expressionism, Pop art pursued no profound aesthetic or social aims. The idea was simply to bridge the gap between mundane contemporary life and art. ■ It was an uncomplicated art, straightforward and easily understood. Ironically cheerful and airy, it reflected the way of life that had emerged from a post-war economy of abundance with cheap and ubiquitous consumer goods, comic books, movie and television entertainment, and advertising. A painted packet of tea (*see below*) could bear comparison with Cézanne's apples. ■ The painter **Richard Hamilton**'s 1957 characterization of its sources has since become famous: "Pop art is popular (designed for a mass audience), transient (short-term solution), expendable (easily forgotten), low-cost, mass produced, young (aimed at youth), witty, sexy, gimmicky, glamorous, big business." A number of artists continued to produce compelling work during the 1960s and later: in England, **Blake**, Hamilton, **Hockney**, **Jones**, **Paolozzi**, and **Phillips**; in America, **Dine**, **Kienholz**, **Lichtenstein**, **Oldenburg**, **Rosenquist**, **Warhol**, and **Wesselmann**.

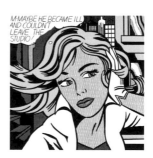

David Hockney, *Tea Painting in an Illusionistic Style*, 1961. Oil on canvas, 198 x 76 cm. Private collection.

Roy Lichtenstein, *M-Maybe* (*A Girl's Picture*), 1965. Magna on canvas, 152 x 152 cm. Museum Ludwig, Cologne.

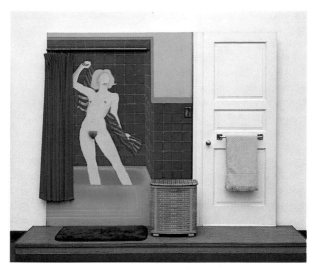

Tom Wesselmann, *Bathtub No. 3*, 1963. Oil on canvas, plastic, various objects, 213 x 270 x 45 cm. Museum Ludwig, Cologne.

The Pop artists took their inspiration straight from contemporary life. They adopted mundane popular imagery, sometimes mounting actual objects on the painting support. They had a predilection for unmixed, bright colors of the kind to which viewers had become accustomed through movie posters, glossy magazine ads, and brochures.

Wesselmann's picture incorporates real bathroom fittings such as a door, towel, shower curtain, laundry basket, and bathmat. The figure is rendered in a flat, schematic way that stands out in stark contrast to the three-dimensional objects.

This work is an example of what is known as **combine painting**, an art form intermediate between painting and a three-dimensional object.

BODY ART AND VIENNESE ACTIONISM

Associated with Happenings and later **Performance art**, Body art (also known as Bodyworks and Body sculpture) exemplifies the extension of modern art during the 1960s and 1970s towards social forums in which the individual can become an artwork. Following Johannes Baader who had performed Dada actions (1918–20), Larionov and Goncharova who used face-paint, and Duchamp who had a star shaved into his hair (1919), in the mid- to late 1960s, sculptors especially turned to making the body itself into art. ■ Perhaps due to a feeling of unease with the body at the time of the sexual revolution, combined with a rebellion against the backdrop of the Cold War, the triumph of science (with the Apollo missions) and Minimalism in art, Body art tended to the extreme, the masochistic, the ritual, or the uncontrolled, and rarely to the poetic, mysterious, or intellectually allusive (as the actions of **Beuys**). It was fundamentally anti-museum, anti-commercial (it remains difficult to sell), socially aware, and disturbing. After early forms by **Yves Klein** (*Anthropométries,* in which naked women were used as "brushes," 1960–61) and **Piero Manzoni** (body "signings," 1959–60 and cans of his excrement, 1961), Body art proper was more concerned with the transformation of the material of the (outer) body: **Brisley** bathed in offal (*And for Today Nothing*, 1972); **Gina Pane** slashed herself with razors (*Azione Psyche* [*Essai*], from 1974); **Acconci** masturbated himself to soreness (1974); **Burden** had himself shot and stuck with pins by members of the public; one of **Abramovic's** actions was stopped when she was bound semi-naked with a pistol in her mouth. Endurance and audience trust were intrinsic to the sacrifice of the body on the altar of art, though the work of **Journiac** and **Lüthi** involved cross-dressing, while Rinke's use of the body as a measuring tool avoided damage to the skin. Many of these actions were either filmed or photographed and hence preserved in more traditional forms. ■ In the 1990s, the body once more came to the fore in art, especially among **Young British Artists**.

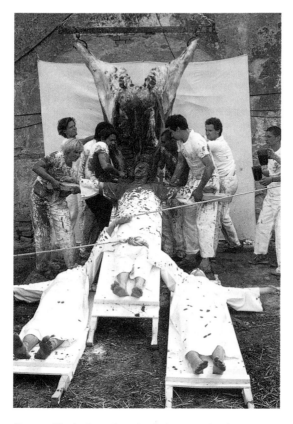

Hermann Nitsch, *Scene from the Orgien-Mysterien-Theater*, 1985. Prinzendorf, Zaya.

The 1960s Body works of Viennese Actionism were more ritualistic in character than other forms of Body art. Especially under the aegis of the Orgien-Mysterien Theater, performance artists **Brus**, **Wiener**, **Muehl**, and "leader" **Nitsch** created quasi-mystical collective actions that mixed religious and even Christian symbolism with the butchery of animals, naked human actors, bizarrely Gothic decors, and music. Muehl also indulged in humiliating solo actions, while **Schwarzkogler** produced private but copiously photographed rituals. The work illustrated was a three-day feast, which incorporated images, music, and odors. The artist stated: "I want to extend the drama into a party." The proceedings were recorded on television.

VIDEO ART

Art recorded on video and conveyed by way of a television or computer screen first came to prominence around 1960, being shown in the context of the activities of **Fluxus** and other **Performance** movements. ■ Video artists show a concern with everything typical of the contemporary age. In a search for the novel and the unexpected, they initially employed TV monitors, and later turned to computer imagery. ■ Video cameras also played a role when it came to recording transitory performances and other events for posterity. ■ Video art indicates the extent to which contemporary approaches to art can diverge from traditional definitions. In fact at one point, it seemed on the verge of supplanting traditional art entirely. ■ Of the many who experimented in the field at that time, only one artist has remained true to video art to today: **Nam June Paik**. ■ Around 1980, artists began to combine video with other materials, creating room-filling multimedia installations which amounted to sculptural-cum-electronic events. ■ These technically sophisticated works astonished and intrigued viewers, and encouraged them to think about television in unfamiliar terms, as an object of art or a communications medium for the aesthetic experience.

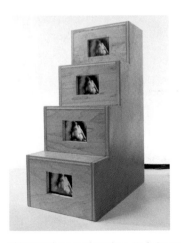

Shigeto Kubota, *Duchampiana, Nude Descending a Staircase*, 1991.
One-channel video installation, four monitors, laser disk, laser-disk player, wood, 53 x 22 x 36 cm. Museum für Neue Kunst, ZKM Karlsruhe.

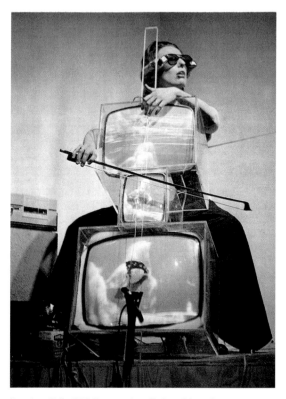

Nam June Paik, *TV-Cello*, 1971. Installation with performance
by cellist Charlotte Moorman, New York.

*TV-Cello was part of an artistic event staged in 1971 in New York,
with the* participation of musician Charlotte Moorman.
The artist built a musical instrument resembling a cello, consisting
of three television monitors and two playable strings. The instru-
ment produced electronic sounds based on a musical score by the
artist. The sound sequence was coupled with changing images on
the screens.

Op Art

Op art is short for Optical art, an art that centers on the effects of visual imagery on the eye. ■ Forerunners of this style included Malevich, Mondrian, the Abstraction-Création artists, as well as the Color Field artists and painters of monochromes. ■ Perhaps the most significant representative of Op art was **Vasarely**. He was already fifty-seven years old when the style reached its brilliant culmination at the second Mouvement Exhibition in Paris in 1965, which invited fifty-one artists from twelve countries to present their work. By this point, artists had been exploring optical effects for years, Vasarely beginning as far back as the 1950s. ■ Characteristic of Op art was the use of small geometrical fields, squares, rectangles, rhomboids, circles, and ellipses, arranged in various patterns on the canvas. These motifs induced virtual configurations which appeared to advance or recede, rotate or vibrate, in effects caused by optical illusion. Two-dimensional paintings were rendered in a way that produced a three-dimensional effect but without recourse to classical perspective. Yet though a concentration on perceptual effects seemed to contain endless potential, Op imagery remained strangely limited in range. ■ Many of the works in this style had a decorative, cool appearance, revealing their basis in technical, scientific thinking. The artist's personal touch played a secondary role. ■ Vasarely trod a different path. Believing a work of art should not remain an original but be repeatable and reproducible, he produced his compositions in many variants, a practice that marked the beginning of serial art. ■ Another important Op artist was **Riley**. Other work of this type included that of **Agam**, **Josef Albers**, **Max Bill**, and **Reinhardt,** and the painters of the **Zero Group** such as **Mack**, **Piene**, and **Uecker**.

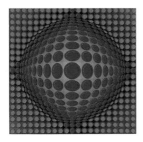

Victor Vasarely, *Vega 200*, 1968. Acrylic on canvas, 200 x 200 cm. Michèle Vasarely.

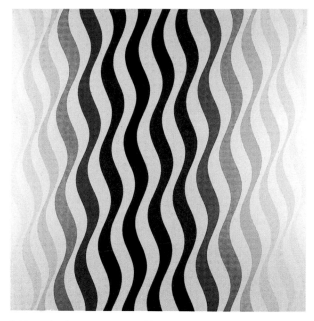

Bridget Riley, *Arrest IV*, 1965. Emulsion on canvas, 179.1 x 179.1 cm.
Luciana Moores.

The wavy lines in Bridget Riley's pictures are a variant of the Op art
repertoire of graphic patterns.

Riley became widely known in 1965 when her wave and stripe
motifs were irreverently adopted by fashion. Without her know-
ledge, New York textile manufacturers printed her patterns on dress
materials, suddenly making Riley an international fashion phenom-
enon. She has long since become a highly respected artist. Combin-
ing intellect, experience, and intuition, she has produced a unique
and personal visual world.

This style began around 1965 in America, and is still focused there today. Alternate terms for Superrealism include Hyperrealism (especially in Europe) and, with regards to painting, **Photorealism**. ■ Several major painters had been working in a realistic style since as early as 1945, including Freud, Guttuso, and Balthus. Pop artists such as Blake and Hockney also refer to themselves as realistic painters. ■ However, the Superrealists depicted reality with the precision and exaggeratedly sharp focus of a camera. ■ The photograph, long used by artists as an aid but treated as a studio secret, now came unashamedly to the fore. ■ A camera is capable of recording details which elude the naked eye. Most Photorealist works are very large in format, and in extreme enlargements things are revealed which most of us have never perceived before. This is probably the source of their fascination. ■ To create a Superrealist painting, a photograph is first projected on the canvas screen, and then the actual painting process begins. ■ Artists working in this style tend to have favorite themes: **Close** depicts close-up faces, **McLean** horses and riders, **Pearlstein** nude figures. **Cottingham** focuses on department store signs, and **Estes** on building facades. **Morley** became famous for his depictions of ships; **Ralph Goings** paints pristine trailers; Briton **John Salt** wrecked automobiles; and **Eddy** reflections in shop fronts. The German artist **Gerhard Richter** occasionally Paints landscapes and nudes in a Photorealist style. ■ Like Pop art before it, Superrealism was a great public success, especially in the United States, where it continued to be popular for several years. In Europe, by contrast, the style has proved short-lived.

Ralph Goings, *Plumbing-Heating Pick-up*, 1969.
Oil on canvas, 114.5 x 162.5 cm. Private collection.

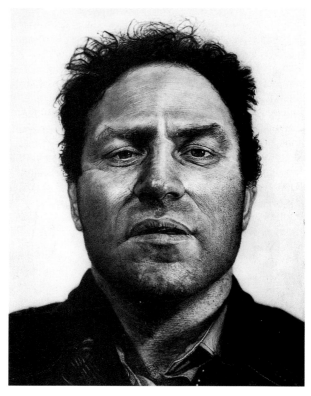

Chuck Close, *Richard Serra*, 1969. Acrylic on canvas, 274 x 213 cm.
Ludwig Forum für Internationale Kunst, Ludwig Collection, Aachen.

Close's portrait of the sculptor Richard Serra was painted with the
aid of a slide projector, its enormous size bringing the tiniest details
into harsh focus. This artist concentrates almost exclusively on the
human head. Close himself confesses that the huge formats he
chooses are deliberately designed to produce a visual, almost vis-
ceral, shock.

Superrealism or Photorealism in painting corresponds to the highly realist work produced by sculptors, the first of which emerged around 1965, in which the figures were actually cast from living models. ■ The main representatives of this extreme realism are Americans: **Andrea** and **Hanson**, though **John Davies** is British. ■ Their sculptures are made by first taking hollow plaster molds from various parts of the body. The molds are then filled with fiberglass and polyester resin, and after it hardens, reassembled into a complete figure. The surface is then rubbed smoothed and painted in natural colors. Finally, the figure is provided with hair and glass eyes. The physical corporeality of the result is astounding to the point that, on first sight, we take such figures to be real. This is exactly what the artist intends—to produce the illusion of reality. In the 1990s, a new vein of Superrealist sculpture appeared in Britain (**Ron Mueck** is an example) and the United States, which favored more disturbing images, often of figures that appear dead or grotesque.

John de Andrea, *Woman on Bed*, 1974. Polyester and fiberglass, painted with oils. Figure 20 x 101 x 20 cm; mattress 15 x 94 x 190 cm. Museum Moderner Kunst, Stiftung Ludwig, Vienna.

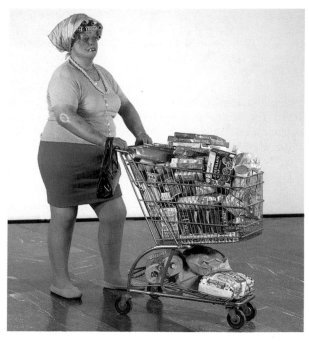

Duane Hanson, *Woman with Shopping Cart*, 1969. Painted fiber-glass, polyester, and articles of clothing, shopping cart with product packaging. Figure 166 x 70 x 70 cm. Ludwig Forum für Internationale Kunst, Ludwig Collection, Aachen.

Superrealist figures like *Woman with Shopping Cart* are both natu-ralistic and illusionistic. They elicit reactions ranging from shock and bafflement to outright embarrassment. Hanson intends his fig-ures to convey a critique of social conditions, as many of his themes show: drunks in the Bowery, cleaning-ladies, drug addicts. He makes everyday mundane reality the focus of his work.

CONCEPTUAL ART

Conceptual or Concept art was the term coined for an art in which idea takes precedence over execution. In about 1965 in both America and Europe, a number of artists began to exhibit conceptions or plans, ideas for works in the form of drawings, texts, or photos, which were intended to encourage the viewer to participate intellectually in the creative process. It was hoped that this involvement in the artist's ideas would lead the public out of its traditionally passive role and activate its imaginative and creative potential. ■ Conceptual artists were no longer confined to producing art works but concentrated on the thought process which precedes making. ■ As a result of their attempts to include the viewer in the process, their works became ever more cerebral as opposed to sensual, and painted images, able to be experienced perceptually and emotionally, grew few and far between. ■ Essentially an art addressed to intellectuals and connoisseurs rather than to the general public, Conceptual art never gained widespread popularity. Nevertheless, it brought forth a number of significant artists, many of whom continued to work in the style for some time. ■ These include **Beuys, Broodthaers, Buren, Burgin, Holzer, Kosuth, Kruger,** and **LeWitt.**

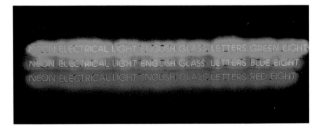

Joseph Kosuth, *Neon Electrical Light*, 1966. Glass letters, neon light. Panzadi Biumo Collection, Milan.

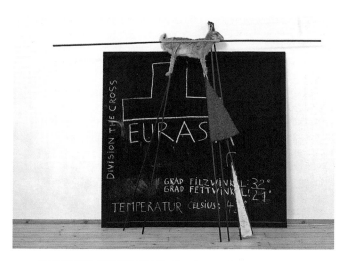

Joseph Beuys, *EURASIA, Siberian Symphony*, 1963
(32nd Movement [EURASIA] FLUXUS, 1966, "Action Tool.")
Blackboard with chalk drawing, felt, fat, hare, metal rods,
Private collection, Munich.

In this work the artist lends more importance to conveying his mes-
sage rationally than to perceptual or aesthetic factors.
It represents an open-ended form of art which gives the viewer an
opportunity to think for himself and follow up the mental associa-
tions prompted by the visual arrangements of objects. This might
well leave viewers who are accustomed to traditional art forms at a
loss. At the time, few art lovers were willing or able to make the
effort to understand works of this type.

MINIMALISM

This was chiefly an East-Coast American movement in the visual arts, originating in the mid- to late 1960s, whose objective approach and extreme simplicity of form reacted against Abstract Expressionism. ■ Modernist abstract art had increasingly eschewed allusions to the "outside" world of representation; minimalism in its turn was to eliminate the "inside" (the artist's personality and gesture) as well. A fascination with this "ground zero" of art dates from at least the early 20th century. Malevich's **Suprematist** squares (1913), and works by Rozanova, Rodchenko, El Lissitzky, and Klein all employed pared-down forms or monochrome. Russian Futurist **David Burliuk** had used "Minimalist" to describe pieces in which "the work [is] the painting itself" (1929). Immediate forerunners in painting in the US included Color Field as well as the geometricism of Albers and Frank Stella's *Stripe* paintings (1958). ■ In Minimalism, the geometries of **Mangold** or **Marden**, the textured monochromes of **Ryman**, and the linear studies of **Agnes Martin**, are distilled "presence," where composition and even color and form are reduced to a trace. It is in sculpture, however, that Minimalism achieves its supreme expression. Composed of simple, geometric shapes, the modern materials—fibreglass, plastic, aluminum—are untreated or colored with primary-color or monochrome industrial paints. The unplinthed "primary structures" (so named after a 1966 exhibition) of **Andre**, **Caro**, **Flavin**, **Judd**, **LeWitt**, **Robert Morris**, and **Tony Smith** are at once statement, sculpture, and painting. In Andre's single-material structures based on a single form, the identical nature of the elements eliminates all expressiveness; in Flavin's colored neon light-tubes, only through the simultaneity of both form and color can either be perceived; in LeWitt's grid-derived objects and wall drawings, calculation predominates; in Morris's neutral grey parallelepipeds *(Untitled [Slab]*, 1968 is a representative title), one can guess at the shape of all sides by viewing just one. Also associated with the trend were **Smithson** (mainly a Land artist), **Grosvenor**, **Bell**, and **Antonakos**.

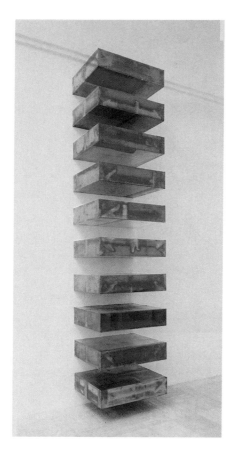

Donald Judd, *Untitled*, 1969. Mirror-finish copper (ten units),
23 x 102 x 292 cm (total height 292 cm). Solomon R. Guggenheim
Museum, New York (The Panza Collection), 1991.

In Judd's industrially produced "specific objects"—the open or
closed metal box-shapes that run cantilevered vertically up a wall—
all expression is eschewed. Judd aspired to a work of wholes, not
parts, that stressed the uniformity of color and shape. A writer on
art and an active promoter of Minimalism, Judd moved to Marfa,
Texas, in 1973, converting buildings there into a multiplicity of stu-
dios in which he produced sculpture, outdoor works, and furniture.

LAND ART

The phenomenon known as Land art began in the United States and Europe around 1968. It involved direct confrontation with the natural environment from which artists took stones, earth, sand, water, trees, and plants as raw material. Land artists brought such materials into galleries or museums and, on the basis of plans, there created works of art. It was an eminently transitory type of art since it could often only be shown at a single venue. The same holds for those Land art works executed out of doors in situ, by means of interference and changes in and reshapings of the existing landscape. These works were sometimes so huge in scale that they could only usefully be viewed from the air. Such pieces were thus presented publicly in the form of documents, complete with drawings, maps, photographs, and written descriptions. As in Conceptual art, the projected work was often not executed at all, the plan or design being more important than the physical execution. Land art was disseminated especially through the activities of **Christo** and **Jeanne-Claude**, **Dibbets**, **Heizer**, **Huebler**, **Richard Long**, **Smithson**, and **de Maria**.

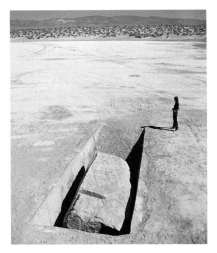

Michael Heizer, *Displaced-Replaced Mass*, 1969. Silver Springs, Nevada. Robert C. Scull Collection, New York.

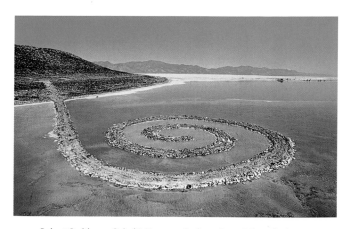

Robert Smithson, *Spiral Jetty*, 1970. Rocks, salt crystals, soil, algae, water, 4.8 x 4.5 m. Great Salt Lake, Rozei Point, Utah (destroyed).

Smithson built *Spiral Jetty* in Great Salt Lake, Utah, in 1970. About as long as five football fields, the work consisted of mud, rocks, and salt crystals. It is probably the best-known example of Land art.
Spiral Jetty lay in a remote area of the lake and was invisible from accessible parts of the shoreline. It was made public only in the form of photographs, drawings, and written documents. In other words, it was a work of art of which only the artist himself had a direct experience.

GRAFFITI ART

Long a boon to model-makers, the use of spray-can paint became a popular phenomenon in 1969 when teenagers in the poorer neighborhoods of New York began spraying it on walls. In 1971 the first newspaper interview with a tagger (sprayer) appeared. ■ The word graffiti comes from the Italian and means something "scratched" or "incised." Since ancient Roman times, the term had traditionally been used to designate the inscriptions and drawings etched on walls in public places. The first modern graffiti art was worked in a single color and contained only the sprayer's name and/or trademark. Such signatures were known as "hits" or "tags." Later they were supplemented by "pieces," or pictorial graffiti. The focus of interest was provided by a word, usually the sprayer's name, the background being formed by a less clearly defined space or surface with zigzag contours. These surfaces were embellished with further decorative motifs such as arabesques, stars, checkerboard patterns, etc., to which written messages or dedications might be added. This type of graffiti rapidly spread worldwide and became an integral part of youth culture. ■ Railroad stations, and especially trains, were a favorite focus of this activity. In New York, two subway trains achieved renown: the Freedom Train, consisting of eleven cars and created in 1976, on the occasion of the U.S. Bicentennial; and the Christmas Train, a ten-car piece of December 1977. When they pulled into the station, people spontaneously applauded—an event which did not prevent the sprayers from being arrested for vandalism. In the 1980s graffiti began to enter art museums, the works of three artists being featured in 1982 at the prestigious Documenta exhibition in Germany: **Basquiat**, **Haring**, and **Quinones**. ■ As an artistic phenomenon, graffiti art was limited to the decade of the 1970s. What is to be seen today on city walls and bridge piers gives an idea of the impact youth culture had on life back then.

New York Subway Graffiti, about 1981.

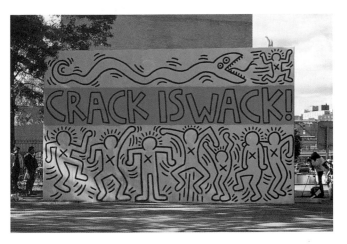

Keith Haring, *Crack is Wack!,* 1986. Mural at East Harlem Drive and
128th Street, New York.

The mostly teenage graffiti artists made direct reference in their
work to the circumstances of their lives. Their paintings on dingy,
unadorned walls, usually in their own depressed neighborhoods,
drew attention to social injustices and inhumanity, or simply assert-
ed their right to a lifestyle outside the mainstream.

Having studied art, Haring turned his back on gallery and museum
art at an early stage and adopted graffiti as what he referred to as a
sign language for everyday communication. He developed a very
personal touch and style, featuring his characteristic simplified con-
tour figures set against a brightly colored background. These were
frequently supplemented by written messages, such as this appeal
to avoid drugs.

NEW FIGURATION

This trend emerged in Germany around 1970 (where it was also known as **Neo-Expressionism**) and rapidly spread throughout Europe and to the United States. Initially there were talented individuals who focused on figurative painting as opposed to abstraction. ■ Although manifold themes were addressed, in the forefront in Germany were an involvement with Fascism, the Holocaust, and the causes of war, as well as representations of the human figure, occasionally evincing an obsessive focus on the sexual act. Whatever the subject, the treatment brought often clashing stylistic elements into play. No period in art history was secure against the artists' eclecticism, as they purloined whatever they felt was best suited to conveying their message. ■ Representatives of 1970s New Figurative Painting in Germany were **Baselitz**, **Immendorff**, **Kiefer**, **Lüpertz**, **Penck**, and **Polke**, and in Austria **Lassnig**. A later, Brücke-influenced variant which produced comprehensible messages in high-key colors, surfaced in Berlin and Cologne under the name **Neue Wilde** [New Wild Ones]. ■ Protagonists in Britain included **Auerbach**, **Bacon**, **Freud**, and **Kitaj**, while in the United States the influence of **Guston** and **Pearlstein** was preponderant. The equivalent movement in Italy was Arte Cifra.

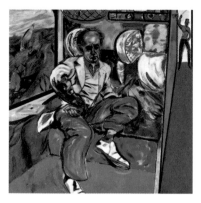

R. B. Kitaj, *The Jewish Rider*, 1984. Oil on canvas,
152 x 152.4 cm. Collection of Michael and Eleonore Stoffel.

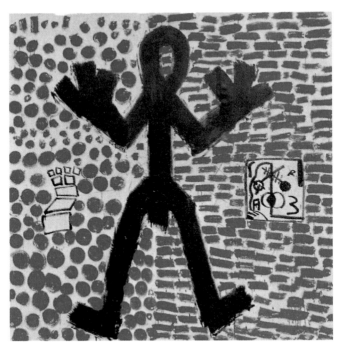

A.R. Penck, *Standart*, 1971. Acrylic on canvas, 290 x 290 cm.
Staatsgalerie Stuttgart.

Penck's paintings are often enormous in size and incorporate corre-
spondingly large abbreviated symbols and pictograms, usually stick
men, with which he populates the canvas in ever new variations.
The majority of his works translate his political concerns and com-
mitment. For many years, the German East-West conflict dominated
Penck's art. The interplay between art and politics continues to be a
central concern.

Italian artists contributed greatly to the revival of painting that commenced around 1980. In fact, one can say that **Postmodern** painting as such began with Arte Cifra, a term that connotes the symbolic encoding of objects, figures, and signs, *cifra* being the Italian for cipher or symbol. It was a figurative approach to painting in which personal feelings, dreams, anxieties, desires, and aggressiveness were recorded in very diverse ways. The style was often emotionally charged and was based on spontaneous communication, though its style could also border on the deliberately banal or vulgar. The subject matter was characterized by unprecedented frankness, reflecting the painters' rediscovery of artistic liberty. A great range of elements were adopted from previous art styles, especially from modern movements such as Surrealism and Pittura Metafisica. Arte Cifra works, strange and disquieting narratives, showed little personal touch, any one painter's style often changing from picture to picture rather than reflecting a defined, individualized approach. ■ All of the painters involved were born after 1945 and included **Chia**, **Clemente**, **Cucchi**, and **Paladino**.

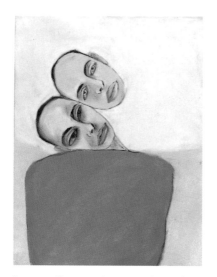

Francesco Clemente, *She and She (Lei e Lei)*, 1982.
Pastel on paper, 61 x 45.8 cm. Thomas Ammann, Zurich.

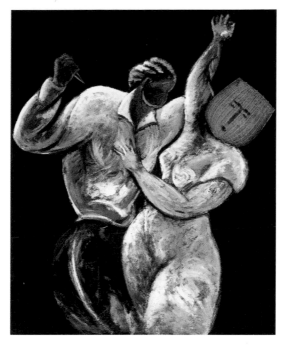

Sandro Chia, *Il volto scandaloso*, 1981. Various media on canvas, 162.5 x 130 cm. Kunsthalle Bielefeld.

Painted in rapid strokes with a heavily loaded brush and in dramatically contrasting hues, this picture shows a menacing encounter between a man and a woman.

Human figures lie at the heart of Chia's work and act out stories derived from a range of periods in art, from ancient Rome to classical modernism. The artist's visual idiom is often so complex in its encoding that it presents the viewer with considerable difficulties in unraveling the message.

NEW IMAGE PAINTING

New Image Painting was an American development that began around 1980 and was inspired by the European styles of Arte Cifra and the **Neue Wilde** (such as Fetting, Kippenberger, and Dokoupil) in Germany. Occasionally it is referred to as New American Expressionism. After the long predominance of Conceptual, Video, and Performance Art, artists and their audience alike longed for a return of painted pictures with a message. A period of realistic, representational art began. Unconstrained and no longer ashamed of telling stories in a readily understandable idiom, paintings were frequently executed from photographs of scenes from everyday American life. Some works, however, were highly critical of social conditions, with subjects such as genetic engineering, vivisection, torture, and cruelty. New Image Painting was an attempt to use art to begin communicating once again and to exert an effect on society. Religious, ethical, and political issues were addressed, in a plethora of techniques, styles, and art forms. Marking the onset of pluralism in painting, never before had such a wide range of aesthetic possibilities been displayed. The very different artists involved, to name only the best known, include **Fischl**, **Golub**, **Kelley**, **Longo**, **Salle**, and **Schnabel**.

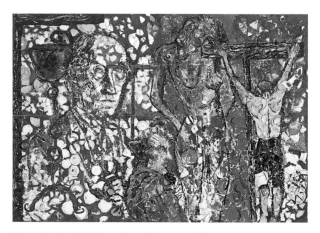

Julian Schnabel, *Painting without Mercy*, 1981. Plates, putty, oil paint, wax, and other materials on wood, 300 x 420 cm. Museum Moderner Kunst, Stiftung Ludwig, Vienna.

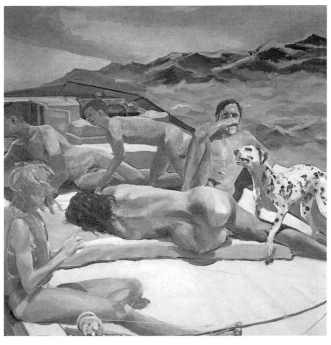

Eric Fischl, *Old Man's Boat, Old Man's Dog*, 1982. Oil on canvas, 213.4 x 213.4 cm. Saatchi Collection, London.

This apparently straightforward subject of five people and a dog on a boat carries undertones of boredom and satiety that suggest a renewed criticism of the "American Way of Life." The viewer is forced into the role of a voyeur, clandestinely observing an intimate situation.

THE PLURALIST SCENE

The regular sequence of art styles and tendencies that began with Impressionism seems to come to an end in the 1980s. The last recognizable groupings were the Neue Wilde in Germany and the protagonists of New Image Painting in America. What followed were manifold, diverse, indeed contradictory, approaches, even within the œuvres of individual artists. The 1980s and 1990s generations entered territory that was alien to fine art as historically defined. Evidently out to tear down every remaining boundary, artists now proceeded to adopt any and every means at their disposal. Besides employing the traditional practices of painting, sculpture, and printmaking, they launched into a plethora of new possibilities and media, often at the same time: sculpture, performance art, film, television, video, photography, computers, design, light and laser, architecture, advertising, music, speech, song, theater.... Nor did artists any longer accept the existence of a gap between contemporary and past art. Through a process of *appropriation*, in their works any style could be presented on an equal footing with any other. Even details from early periods such as Renaissance, Baroque, Rococo, Neo-Classicism, or Romanticism were blithely incorporated into innovative compositions. The new communications media played a key role too, enabling the almost instant dissemination of art, even entire exhibitions, around the world. As European borders grew permeable, artists traveled more freely, and an association of particular names and styles with specific nations became increasingly irrelevant. Artists from other continents entered the art scene, enriching it with new, surprising approaches and ideas. ■ In view of this extreme variety, it is no longer meaningful to list individual artists' names in the descriptions of trends and approaches that follow. Pluralism is the mark of artistic developments in the waning years of the 20th century and at the onset of the new millennium.

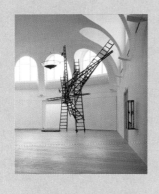

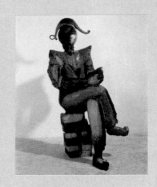

141

Even within the confines of the conventional medium of painting, by the 1980s the variety of Pluralism knew no bounds. One thing had remained unchanged, however—painting was still a means of expression employing brush and paint on a solid support. As computer, scanner, and printer began to supplant the classical means, artistic authorship and originality were increasingly called into question by new technology. In the 1980s and 1990s, painting continued to be divided into primarily representational versus non-objective approaches. ▪ The interest shown by artists in painting traditions also remained significant. Even the virtuoso techniques of the Old Masters were sometimes adopted, and their compositions were "quoted" or "appropriated" in many young painters' works. Their subject matter, too, seemed timeless—portraits, figures, myths, emotional states, dreams, anxieties, sickness and death, social conditions and current events. These were supplemented by themes from our modern world of technology, science, literature, and music. ▪ As from time immemorial, artists painted pictures so as to trigger feelings in the viewer, to arouse his or her curiosity or concern. But like much early modern production, in recent years such art has seemed enigmatic to a wider audience.

Peter Halley, *CUSeeMe*, 1995.
Acrylic, Day-Glo, and Roll-a-Tex
on canvas, 174.5 x 280 cm. Goetz
Collection, Munich.

Josef Mikl, *Figure with Blue Wall*,
1992–93. Oil on canvas,
198 x 198 cm. Essl Collection,
Vienna-Klosterneuburg.

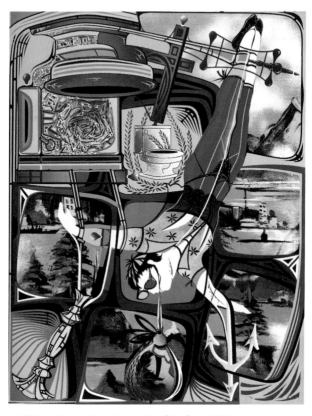

Lari Pittman, *Once a Noun, Now a Verb (No. 2)*, 1998. Oil on canvas, 122 x 91 cm.

"What has a place in a painting?" asks Lari Pittman, and replies, "All the abundance of life, including its silly, frightening, and romantic aspects."

A new generation of sculptors emerged in this period. In the 1970s there had been much interest in sculptures which were characterized by an extremely sparing, minimalistic form. Now all that changed as sculptures grew more detailed, complex, and often colorfully painted—polychrome, to use the technical term—and accordingly began to convey more levels of meaning. ■ Today's sculptors no longer limit themselves to working with the tried and tested materials of stone, wood, metal, and ceramics. They also employ modern industrial products such as synthetic resin, plexiglass, styrofoam, plastic sheeting, plywood, and concrete. As these materials are not freighted with tradition they offer an open field of experimentation in which the artist can achieve unprecedented results. ■ Many sculptors insist on not being grouped together with installation artists, since their prime concern remains the freestanding figurative or abstract sculpture.

Magdalena Abakanowicz,
Armless Backs, 1992. Sackcloth
and resin, 51 separate elements,
height 77–80 cm each.
Museum Ludwig, Cologne.

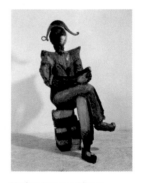

Markus Lüpertz, *Pierrot
Lunaire*, 1984. Painted bronze,
140 x 100 x 100 cm. Private
collection (D. Hauert, Berlin).

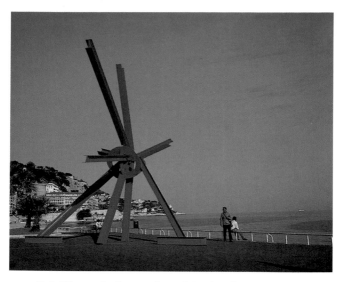

Mark di Suvero, *Tendresse*, 1989–90. Painted steel,
900 x 650 x 940 cm. Gagosian Gallery, New York.

This monumental sculpture stands on an open plaza, and its shapes
project into and re-configure the surrounding environment.
The visual concept is simple: an open framework of beams whose
lines intersect at a central point. Despite its overwhelming size and
the geometrical severity of its design, the piece conveys an impres-
sion of lightness and grace. The elements swirling round the central
intersection point as if holding it in an embrace, suggested by the
sculpture's title: *Tendresse* [*Tenderness*].

Until recently, artists who worked in the medium of photography relied on conventional means whose deployment required considerable technical skill and aesthetic sensibility. If they wanted to transform the reality presented in a photograph, they had to resort to the darkroom and its chemical processes or else to use old retouching techniques and scissors and paste (**photomontage**). Nowadays a considerable number of photo-artists employ digital technology. Images are made with a digital camera, fed into a computer, manipulated with the aid of a dedicated photo program, and printed out on a laser printer. These new methods have already proven capable of surpassing traditional photographic techniques in terms of variety of focus, color, and contrast. ▪ Now photo-artists are in a position to configure their own virtual reality. Photography has transcended the stage of reproduction to become a creative medium in its own right. ▪ In fact, it was not until 150 years after its invention that photography was truly given a significance equal to that of the classical media of painting, printmaking, and sculpture, at an exhibition, the 1977 Documenta held in Kassel, Germany.

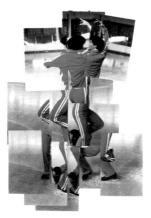

Jeff Wall, *Milk*, 1984. Cibachrome transparency, 187 x 229 cm. FRAC Champagne-Ardenne, Paris.

David Hockney, *The Skater, New York*, December 1982. Montaged polaroids, 66 x 49.5 cm.

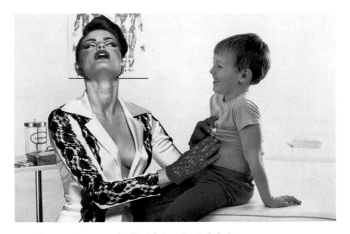

Inez van Lamsweerde, *Stretch-Lace Pants Suit: Petra*, 1994.
Two-color computer montage, 120 x 180 cm.

This photograph was composed of various existing photo images manipulated on a computer monitor, stored on the hard drive, and printed out in a large format. The artist has employed a digital design program to create a striking virtual image.

The use of emitted light in art began in earnest around 1920 with experiments at the Bauhaus. Around 1960, members of the German group, **Zero**, began to concentrate on works in this mode while like-minded artists in Southern California invented Light-and-Space Art. Such "light architectures" combined light with space, color with movement. Light became a "dynamic, plastic material" in their hands. ■ On today's scene—with its love of experiment and its search for ever-new materials to convey novel ideas—artists have rediscovered the potentials of artificial light, a phenomenon which can take a range of forms. ■ The neon tube, that stalwart of public advertising, possesses a malleability that permits the creation of brilliant and colorful configurations. ■ Holography, with its perfect illusion of corporeality and potential for deep space, has developed into the art form of photographic sculpture. ■ Video art, until recently limited to the dimensions of the TV monitor, can now be projected onto large-format screens. ■ Laser beams are being employed to convey artistic statements on a gigantic scale. ■ In short, light has become a compelling means of expression in the hands of many inventive contemporary artists.

James Turrell, *Side Look*, 1992. Installation with fluorescent light, tungsten fanlight, and daylight. Städtische Galerie im Lenbachhaus, Munich.

Dan Flavin, *Untitled (To My Dear Bitch, Airily)*, 1984. Fluorescent light, 1.57 x 17.32 m. Exhibited at the Leo Castelli Gallery, New York. Artist's collection.

Bruce Nauman, *Human Nature/Knows Doesn' t Know*, 1983–86.
Neon tubing, 230 x 230 x 35.5 cm. Fröhlich Collection, Stuttgart.

Today's changing definitions of art become apparent in this neon
work with its reliance on the effects of light emitted from a man-
made device.
Conveying the sheer magic of colored light, it also translates a
sense of the artist's love of experiment as well as a playful handling
of typographical layout and philosophical allusion.
The material employed—neon tubing—is a familiar feature of daily
life and is used widely in advertising. This quite naturally prompts
us to compare its artistic and commercial utilizations, and gives
much food for thought on the contemporary definition and meaning
of art.

Many artists have found the traditional media of painting, sculpture, and printmaking inadequate to convey their intentions. Their search for more immediate and all-embracing means of expression has led to the idea of the installation. This is a combination of various objects and materials displayed in an real room, purpose-made or else pre-existent, as in the case of a gallery or museum space. The elements used are either taken from the environment or made to order by the artist. ■ Installations are frequently created for the duration of the exhibition only and preserved for posterity in photographic or video form. ■ Installations are designed for a variety of purposes: as a reaction to everyday experience, as an urge to record memories of the past, or as an expression of hope for the future. The list of possible media is endless: familiar objects and materials from the home, domestic appliances like radios and television sets, fashion items, neon signs, pictures, photos, and books—anything can be co-opted into a new and original environment. Augmented by music, voice recordings, or video, an almost theatrical space is constructed which can frequently actually be entered by viewers. They experience a new, unprecedented world, a context in which the familiar becomes strange—a transformation which is the essence of art.

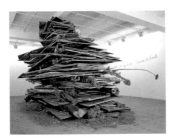

Anselm Kiefer, *Twenty Years of Loneliness*, 1971–91. Installation: paintings, books, seeds, and mixed media, dimensions variable. Marian Goodman Gallery, New York.

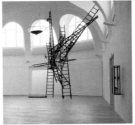

Rebecca Horn, *Tower of the Nameless*, 1994. 1997 Installation: ladders, violins, metal structures, glass funnels, iron, water, hoses, pump, and copper rods. Kestner Gesellschaft, Hanover.

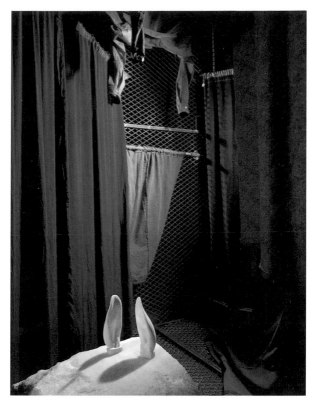

Louise Bourgeois, *Cell VIII*, 1998. Hexagon of welded-wire latticework, wall hangings, blue dresses, rough-hewn marble block with rabbit-like ears. Artist's collection.

Internationally renowned for the amazing powers of innovation she has shown over the many decades of her career, Louise Bourgeois (born 1911) was honored by the commission of Tate Modern for this installation, presented to the public in May 2000.

The Argentine writer Borges would often use the metaphor of a Universal Library which could house all utterances in every language. The world wide web has almost realized his dream: in a second, the average search engine scans more than a billion webpages and counting. Museums use virtual space to inform the public and universities put up art education sites, while galleries exhibit and even sell on-line. Independent artists of traditional media also show photographs of their pieces on the web. It may well be that such developments will change the role of galleries. ■ Internet or online art, however, does not cover such phenomena. It describes digital art designed to be accessed via phone lines on (at present) computers plugged into the Internet. It can either be put up by an individual and remain as it is, even if connected to other similar sites by way of clickable "hyperlinks" on the screen or "page," or else it can actually be created by visitors to the website, by way of special programs that can be directly manipulated or that respond to preferences expressed in normal language or to images downloaded to the host from the viewer's computer. ■ Whereas computer art of the 1960s tended to be repetitive and mathematical in nature (and aesthetically the results were often disappointing), huge advances in loading speeds and print quality have made internet art viable. Many of the art projects online, however, are not "purely" aesthetic (in this, they mirror the art scene generally), and tend to concern the social nature of art: cultural censorship, copyright, and appropriation, graffiti bulletin-boards, art appreciation voting games, museums of "bad art," and so on. Other work centers on "genetic manipulation" of an art object, allowing it to grow automatically as information is fed into a development program by new users. ■ The question as to whether such art is truly democratic, artistically worthwhile, marketable (is art only to be accepted once certain people buy it in certain spaces?), and original preoccupies practitioners as much as commentators. One can be sure of one thing, however: internet art, like all online phenomena, will be hybrid. It will also provide a further forum for art which is unlikely to compete with exhibitions in general: whether the best art will in future be confined to virtual media, however, thereby marginalizing "real" spaces, only time will tell.

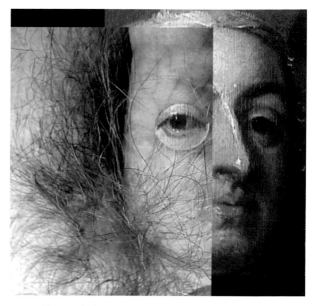

Harwood@mongrel, *Skin, Hair, and The Du Cane Boehm Family Group: After Gawen Hamilton*, 1734–2000 (detail).

Uncomfortable Proximity is one of two internet projects commissioned by Tate in 2000 for its website (www.tate.org.uk). Harwood's montages—"the curdled fragments of cultural history" according to one reviewer—take works from the Tate Collection (Turner, Hogarth, Gainsborough etc.), break them down, and reconstruct them, this time making visible the history of poverty and exploitation which underlay the fortunes of the gallery's patrons, including founder and sugar baron Sir Henry Tate. This "Tate mongrel" website appears automatically alongside the official Tate site, mirroring its content and structure but subverting it. It is a perfect example of how internet art can question the assumed neutrality of information provided on the web.

THE MILLENNIAL SCENE

The hype surrounding the Millennium did not and could not signal a sea-change in the nature of art. The period, however, does provide an opportunity for re-evaluating the current situation. Does hope or despair win out? ■ Some differences between art now and art of, say, thirty years ago, are patent. Art is now disparate: no one style dominates, no one country can lord it over others. If money remains centered in the United States and Europe, the arrival of countless artists on the Western scene, not only from prosperous Japan, but from poorer Africa and Brazil and formerly closed China, means that the market is spreading worldwide. Art in the West too has fractured: the buzzword is identity, be it personal (much art is confessional in tone) or collective (as in so-called "identity politics": black British art, **Chicano art**, **Neo-Feminist art**, and so on), and there is no all-embracing ideology, not even democracy. ■ Curiously in this context, artists without a particular ax to grind often seem weighed down by those stalwarts in uncertain times: shock tactics and irony. "Obscenity" and appropriation (the use of earlier art products or forms) are all-pervasive. Critics vie with artists to illuminate ever-darker recesses of ironic reference (especially to kitsch), and art can look like a game of hide-and-seek pitting originality against a historical awareness. In the late 1990s this brought the playful vogue for almost desultory approaches (**"Slacker," "Scatter,"** and **"Pathetic" art**) which for a time derided the portentousness of installation and art criticism. ■ The budding artist of today needs what is called in advertising a "concept," a catch-all tag which can be readily applied to his/her work so that it is recognizable, preferably from the other side of the street. An artist who switches style, even if this itself is mix-and-match, risks being lost in the crowd. Only when "established" (and in the present commercial climate, who can say when that is) may an artist branch out. From this stems the Hollywoodization of the artist: around 10 are known to the public (the "A"-list), and the rest are bit-players who become marketable when they win one of the annual media circuses called art prizes. The "tabloid," party-

going persona of the artist becomes an art work in itself: one, however, seemingly bereft of the meaning given such activities in the past by, say, Duchamp. ■ Mirroring Western production generally, craftsmanship takes a back seat: the majority of artists now farm out the making of the artwork to professionals and thus act as intellectual "service industry franchises" whose "label" is all important. ■ An important change was symbolized by a recent book on British art today. Out of 180 text pages, only 80 were devoted to artists, with 100 pages on other "players," from publicists to "spaces." The jury is out on whether the pre-eminence of the gallery and (in mainland Europe) of the state contemporary art space will really be undermined by internet art. Virtual art itself throws up the question of how it can be "owned" and the same doubts surround installation, which remains a marginal form. ■ Modern, as against contemporary, art is doing well. Ducking and diving to glimpse a Picasso—or even a Pollock—at a blockbuster show is now as much a part of middle-class life as the July queues at the Uffizi. Are such huge exhibitions (and their 500-plus-page catalogs) useful? ■ The belief of the public in such events contrasts with the baffled amusement that greets the most outrageous products of contemporary practitioners. As in the past, some proclaim that now "art (really) is dead"— though not because it lacks vigor (until the next price crash anyway), but because it so often feels compelled to compete with other demands on the attention span of its audience (from movies and murder stories to racism and Millennial celebrations). Now a product like any other, art, after so painstakingly rejecting successively "representation" (Abstract), "originality" (Dada), "content" (Minimalism), and "style" (Appropriation) over the past eighty years has now successfully jettisoned its "identity" as well. What next?

D.R.

1874 France: Beginning of **Impressionism**. first Impressionist exhibition in Paris : Degas, Manet, Monet, Pissarro, Renoir, Sisley. Other artists close to Impressionism included: Cézanne, Gauguin, van Gogh, Matisse, Toulouse-Lautrec.

1882 England: **Arts & Crafts movement** founded by William Morris.

1883 Progressive exhibition society Les XX ("The Twenty") set up in Brussels.

1886 France. Beginning of **Neo-Impressionism**: Seurat, Signac, ˙ Pissarro, employing the **Pointillist** (**Divisionist**) brushstroke.

1886 Europe. **Symbolism** founded: Gauguin, Hodler, Khnopff, Klimt, Moreau, Puvis de Chavannes, Redon, Segantini, Toorop.

1889 France. **Nabis** group formed: Bonnard, Denis, Roussel, Sérusier, Vallotton, Vuillard.

c. 1890 Pictorialism dominant in photography: Cameron, Demachy, Puyo.

1890 Art Nouveau and **Jugendstil** appear: Klimt, Thorn Prikker, van de Velde. Other **Symbolist-Jugendstil** influenced masters: Hodler, Munch.

1892 Munich Secession of independent artists formed.

1893 German Impressionism: Liebermann, Corinth, Slevogt.

1896 Divisionism the dominant Post-Impressionist current in Italy.

1870 France defeated in Franco-Prussian War.

1871 Establishment of the Paris Commune.

1874 Development of the paint-tube enables artists to work more easily outside the studio [*en plein air*].

1876 First telephone in use in US.

1878 Invention of the filament lamp-bulb that will change the lighting atmosphere in artists' studios.

1880 The French railway network expands, enabling artists to travel rapidly to country areas.

1881 Tsar Alexander II assassinated; reaction includes Jewish pogroms and expulsions.

1885 Cologne cathedral tallest built structure in the world, only to be surpassed by the Eiffel Tower (1888). Brazil outlaws slavery.

1893 In Paris, the arrest of the first striptease artiste (a sculptor's model) provokes student riots.

1897 Vienna Secession established.

1899 Berlin Secession established.

1900 Exposition Universelle in Paris: showcase for decorative arts.

1905 Paris: the Salon des Indépendants stages a vast show comprising 4,270 entries by contemporary artists.

1905 Dresden. Founding of the **Die Brücke** group: Heckel, Kirchner, Mueller, Pechstein, Schmidt-Rottluff. Nolde joins later.

1905 France. **Fauves** founded: Derain, van Dongen, Dufy, Matisse, Vlaminck.

1907 France. Beginning of **Cubism**: Braque, Gris, Léger, Picasso.

1909 Germany: Founding of the **Neue Künstlervereinigung München**.

1909 Italy. **Futurist** Manifesto by Marinetti published. Artists: Balla, Boccioni, Carrà, Russolo, Severini.

1910 Kandinsky paints the first purely **abstract** works and writes the first theoretical exposé on abstract color and form theory, *On the Spiritual in Art* (published 1912).

1911 Germany. **Blue Rider** [**Blaue Reiter**] founded: Jawlensky, Kandinsky, Klee, Macke, Marc.

1912 France. **Orphism** developed: Robert and Sonia Delaunay, the Czech artist Kupka.

1894–98 Anti-Semitic case against Dreyfus rocks France: accused of spying and imprisoned, the officer will be exonerated, before being restored to rank in 1906.

1895 Birth of the cinema. Discovery of X-rays.

1899 Sigmund Freud, *The Interpretation of Dreams,* and Thorstein Veblen, *Theory of the Leisure Classes* (on "conspicuous consumption"), published in German.

1900 Development of quantum theory by Max Planck. Recording of the first gramophone disk.

1903 First powered airplane. Flat-Iron Building completed in New York City, reaching 69 m in height.

1905 Albert Einstein announces his Special Theory of Relativity ($E=mc^2$): his General Theory follows in 1906.

1906 Earthquake practically destroys San Francisco.

1908 First conveyor-belt assembled automobiles.

1909–13 Diaghilev's *Ballets Russes* (with Stravinsky, Nijinsky, and Pavlova) perform in Paris to scandal and acclaim.

1909 Manufacture of the first artificial fiber. Explorers reach the North Pole.

1911 Explorers reach the South Pole.

1911 *Mona Lisa* stolen from Louvre (recovered 1913).

1913 First **avant-garde** exhibition in the US: The Armory Show.

c. 1913 Russia. Beginning of **Constructivism** and **Suprematism**: Gabo, El Lissitzky, Malevich, Pevsner, Rodchenko, Tatlin.

c. 1913 England. Founding of **Vorticism**: Lewis, Bomberg, Nevinson, Epstein.

1915 Dada. In Zurich: Arp, Richter; in Germany: Ernst, Schwitters, Hausmann.

1917 Dada in New York: Duchamp, Man Ray, Picabia.

1917 Holland. **De Stijl** founded: van Doesburg, Mondrian, Vantongerloo, Rietveld.

1917 Italy. **Pittura Metafisica** developed: Carrà, de Chirico, Morandi.

1918 Germany. **Novembergruppe** founded: Baumeister, Dix, Feininger, Grosz, Heckel, Itten, Kandinsky, Klee, Meidner, Moholy-Nagy, Pechstein, Schmidt-Rottluff, Schwitters.

1918 Germany. **New Objectivity** (**Neue Sachlichkeit**) begins: Beckmann, Dix, Grosz, Hofer, Radziwill, Schad, Schrimpf.

1919 Dada launched by Picabia in Paris.

1919 Germany: **Bauhaus** founded. Teachers included: Albers, Feininger, Gropius, Itten, Kandinsky, Klee, Marcks, Mies van der Rohe, Schlemmer.

1912 Schoenberg, *Pierrot Lunaire*: atonal Expressionism in music.

1914 Outbreak of First World War.

1915 First use of poison gas in the trenches. Franz Kafka's novella *Metamorphosis* is published in German.

1916 The first artificial limbs developed for the war-wounded.

1917 First use of airplanes for military purposes. March: abdication of Russian Tsar. October: Russian Revolution. C. Jung. *Psychology of the Unconscious* published in German (on "collective unconscious")

1918 End of First World War. Civil war in Russia. Following his atonal works in 1908, composer Arnold Schoenberg devises "twelve-tone row composition": structured abstractionism in music.

1920s Appearance of **South American Muralism**: Rivera, Orozco, Siqueiros, Leal, Revueltas, Benton, Guayasamín, Portinari, Tamayo.

1924 France: Breton's *Manifesto of Surrealism* published. Artists included: Arp, de Chirico, Dalí, Ernst, Magritte, Man Ray, Masson, Miró, Tanguy.

1931 France. **Abstraction-Création** group founded with 400 international geometrical abstract artists including: Albers, Arp, Baumeister, Bill, Robert Delaunay, van Doesburg, Gabo, Kandinsky, Kupka, Le Corbusier, Léger, El Lissitzky, Moholy-Nagy, Mondrian, Ben Nicholson, Pevsner, Schwitters, Vantongerloo.

c. 1931 American Scene Painting emerges: Benton, Curry, Grant Wood, Biddle, Levine, Arnautoff, Shahn, Fogel.

1932 Russia. **Socialist Realism** appears: Plastov, Gerasimov, Popkov, Brodski, Merkurov, Mukhina, Deineka.

1933 Germany. Institution of Nazi official art established. Artists forbidden to paint and exhibit included: Baumeister, Dix, Heckel, Hofer, Nolde, Pechstein, Rohlfs, Schlemmer, Schmidt-Rottluff. Others went into foreign exile, including: Albers, Beckmann, Feininger, Grosz, Hartung, Kandinsky, Klee, Kokoschka, Schwitters.

1937 Opening of the **entartete Kunst** [degenerate art] show in Munich (then on to numerous other cities), as Nazi-controlled museums empty of modern art.

1920 Communist but anti-state naval uprising at Kronstadt violently put down on Trotsky's orders. Women get the vote in the US.

1921 Ludwig Wittgenstein's *Tractatus Logico-Philosophicus* is published.

1922 The film *Nosferatu,* by F.W. Murnau, appears.

1927 Werner Heisenberg publishes his *Uncertainty Principle.*

1928 Development of the cartoon industry: Mickey Mouse, Superman, and Batman.

1929 Wall Street Crash in US; beginning of world recession.

1930 Stalin begins "liquidation of the kulaks [owner-farmers] as a class."

1932 Famine in Soviet Russia. Gödel's Undecidability Theorem undermines intuitive foundations of arithmetic.

1933 Hitler becomes Chancellor of Germany prohibiting other political groupings, and begins to control the press.

1936 Outbreak of civil war in Spain. Olympics in Berlin staged as a Nazi pageant, but black American Jesse Owens is the athletics hero. BBC sets up first electronic TV system in Britain.

1938 Discovery of nuclear fission using neutrons, making the development of atomic energy possible.

1937 Picasso paints anti-war *Guernica*. Guernica was a Spanish village destroyed by Fascist bombs in the Civil War.

1945 US and Europe: **Abstract Expressionism** begins. US: Gorky, Kline, de Kooning, Motherwell, Newman, Pollock, Rothko. Europe: Alechinsky, Appel, Baumeister, Bissière, Burri, Corneille, Fautrier, Fontana, Götz, Hartung, Jorn, Manessier, Mathieu, Poliakoff, Saura, Schumacher, Soulages, Nicolas de Staël, Tàpies, Vedova, Vieira da Silva, Winter, Wols.

1945 Beginning of **Tachisme** in Europe: Baumeister, Fautrier, Götz, Mathieu, Nay, Schumacher, Wols.

1948 Compagnie de **l'Art brut** founded in France by Dubuffet.

1948 Europe-wide **Cobra** group formed: Alechinsky, Appel, Constant, Corneille, Jorn.

1950 US. Beginning of **Color Field Painting**: Hoyland, Kelly, Newman, Noland, Rothko, Frank Stella.

1955 Opening of quadrennial Documenta exhibition in Kassel.

1955 US and Europe. Beginning of **New Realism**: Arman, Johns, Klein, Rauschenberg, Spoerri.

c. 1955 US. Term **Hard-Edge Painting** coined by US critic Jules Langner. Artists: Kelly, Al Held, Youngerman, Frank Stella, Noland, Leon Polk Smith, Liberman, Agnes Martin.

1939 Outbreak of Second World War.

1945 Second World War ends when US drops atom bombs on two Japanese cities. Soviet troops liberate Auschwitz and the Allies enter Dachau concentration camp, revealing the scale of the Nazis' "Final Solution." Nuremberg Trials of former Nazi leaders begin.

1945 The first digital computer is unveiled (ENIAC).

1947 Economic reconstruction of Europe through the US Marshall Plan.

1949 Founding of NATO. Simone de Beauvoir's *The Second Sex* published: in the 1950s, her lover Jean-Paul Sartre's Existentialism becomes the first philosophical "fad."

1950s The "Beat Generation" (Allen Ginsberg, Jack Kerouac, etc.) unite US East and West Coast traditions in the first "hip," "pop," and jeans-wearing literary movement.

1952 Publication of structure of DNA.

1955 Nabokov's *Lolita* published.

1957 First satellite (USSR's Sputnik) launched into space. Roland Barthes' *Mythologies* offers an analysis of consumerism in aesthetic and social terms (English translation 1972).

1958 US and Europe. **Performance art** and **Happenings**: Beuys, Dine, Kaprow, Klein, Oldenburg, Rauschenberg, Vostell.

c. 1960 US. Unconventionally **shaped-canvas** works appear: Kelly, Frank Stella, Noland, Bolotowsky, Richard Smith, Hinman, Feeley, Ron Davis, Murray, Ed Ruscha.

1960 US and Britain: **Pop art** fully established. US: Dine, Kienholz, Lichtenstein, Oldenburg, Rosenquist, Warhol, Wesselmann. England: Blake, Hamilton, Hockney, Jones, Paolozzi, Phillips.

1960 Beginning of **Viennese Actionism**: Brus, Muehl, Nitsch, Schwarzkogler, Wiener.

1960 US and Europe. **Video art** appears: Nam June Paik.

1965 US and Europe. **Op art** reaches its peak: Agam, Josef Albers, Max Bill, Reinhardt, Riley, Vasarely, and the Zero group: Mack, Piene, Uecker.

1965 US and Britain. Beginning of **Superrealism**: Close, Cottingham, Eddy, Estes, Goings, McLean, Morley, Pearlstein, John Salt; sculptors Andrea, John Davies, Hanson, Kanovitz.

1965 US and Europe. **Conceptual art** appears: Beuys, Broodthaers, Buren, Burgin, Holzer, Kosuth, Kruger, LeWitt.

1965 US and Europe. Beginning of **Minimalism**: Andre, Caro, Flavin, Judd, LeWitt, Mangold, Marden, Agnes Martin, Robert Morris, Ryman, Tony Smith.

1960 First laser built. Ban on D.H. Lawrence's *Lady Chatterley's Lover* (1926–27) lifted after obscenity trial.

1961 First manned space mission. Building of the Berlin Wall.

1962 Cuban missile crisis brings USA and USSR to brink to nuclear war. Algeria gains independence from France after violent campaigns of terrorism and repression.

1963 Assassination of President John F. Kennedy: conspiracy theories abound. Beatlemania hits UK and US.

1965 Outbreak of Vietnam War involving US. First spacewalk.

1965 The Rolling Stones' single "I can't get no Satisfaction" released. Appearance of the mini-skirt.

1967 Six-Day War between Israel and Arab nations.

1967 Canadian Pop culture theorist Marshall McLuhan, states that "the medium is the message."

1968 US/Europe. Start of **Land art**: Christo and Jeanne-Claude, Dibbets, Heizer, Huebler, Richard Long, de Maria and Smithson.
1969 US. **Graffiti art** appears: Haring, Basquiat, Quinone.

1970 Europe and US. Beginning of **New Figuration**. Germany: Baselitz, Immendorf, Kiefer, Lüpertz, Penck, Polke. Britain: Auerbach, Bacon, Freud, Kitaj. US: Guston, Pearlstein.

c. 1980 Italy. Beginning of **Arte Cifra**: Chia, Clemente, Cucchi, Paladino.

c. 1980 Germany. **Neue Wilde** emerges: Fetting, Kippenberger, Dokoupil.

1980 US. Beginning of **New Image Painting**: Fischl, Golub, Kelley, Longo, Salle, Schnabel.

1980 Picasso blockbuster exhibition at New York's MOMA.

1981 "A New Spirit in Painting" exhibition at Royal Academy of Arts, London, heralds success of **Neo-Expressionism**.

1982 "Transavantguardia" at Galleria Civica, Modena, showcases Italian figurative art.

1983 **Graffiti art** exhibition at Boymans-Van Beuningen Museum, Rotterdam.

1984 "Primitivism in 20th-Century Art" at MOMA, New York, with an influential catalog by William Rubin; Neue Staatsgalerie, Stuttgart, Germany opens; Saatchi Gallery, London opens with catalog *Art of Our Time*.

1968 May–June: student riots, especially in Paris. Deconstruction (theories by Jacques Derrida, Michel Foucault and others) becomes fashionable on literary campuses in France then US, leading to a blurring of the distinction between "criticism" and "artwork."

1969 Anglo-French supersonic aircraft Concorde links Paris to New York at 2,300 km per hour. Apollo 11 lands on the Moon.

1973 First of the great blockbuster exhibitions in London and US: "The Treasures of Tutankhamun" at the British Museum.

1974 Watergate scandal ends Richard Nixon's presidency in the US.

1980s Conservative Reaganism (1980) in US and Thatcherism (1979) in UK bring reductions in state funding of the arts; in France, President François Mitterrand (1981–95) takes a more pro-arts approach.

1981 Walkman marketed. Industrial microprocessor-controlled robots introduced. MTV starts on US TV.

1983 HIV infection and AIDS formally identifed. Video-cassettes, camcorders, and CDs launched.

1983 Invention of the Internet in US.

1984 First personal computers (PCs) marketed.

1986 Opening of Centro de Arte Reina Sofia, Madrid, and Museum Ludwig Cologne; "Neo-Geo" exhibition, Sonnabend Gallery, New York; "Sots Art" exhibition at Museum of Contemporary Art, New York, alerts US public to *perestroika*-influenced Soviet art.

1987 "Modernidade: art brésilien du 20e siècle" at Musée d'Art Moderne de la Ville de Paris; van Gogh's *Irises* (1889) auctioned in New York for $53.9m.

1988 "Freeze," an informal London exhibition of New British Art, many of whose exhibitors later become known as "Young British Artists".

1989 "Magiciens de la terre" at Centre Pompidou, Paris; "Art in Latin America," at Hayward Gallery, London; an exhibition at Corcoran Gallery, Washington DC, by gay photographer Robert Mapplethorpe who dies of AIDs that year is cancelled; photographer Andres Serrano's work is also accused of blasphemy; Richard Serra's *Tilted Arc* metal sculpture is removed after fears for public safety.

1990 Ilya Kabakov, "He lost his mind, undressed and ran away" in New York; the "Decade Show" in museums in New York sets a multicultural agenda; van Gogh's *Dr. Gachet* (1889) is sold for $82.5m; 12 objects valued at $200m are stolen from the Isabella Stewart Gardner Museum, Boston. The trend for "unstructured" ("Pathetic," Slacker" art, etc.) begins.

1985 Gorbachev comes to power in USSR.

1986 Accident at the Chernobyl nuclear reactor.

1986 World Trade organization established.

1988 Soviet army withdraws from Afghanistan after 9-year war.

1988 Experiments in genetic modification of animals begin.

1989 Opening of the Berlin Wall. Beginning of the collapse of the Soviet bloc.

1989 Chinese apply martial law in Tibet.

1989 Electron-positron supercollider in Switzerland probes ultimate components of matter.

1990 East and West Germany reunified.

1990 Democratic elections in Poland, Lithuania, Yugoslavia, and Hungary. Apartheid unravels in South Africa.

1991 Art price crash particularly affects contemporary works; founding of British *Frieze* magazine that publicizes Young British Artists.

1992 "Post Human" FAE/MAC, Pully/Lausanne; "Young British Artists", Saatchi Gallery, London; opening of Museo Thyssen-Bornemisza, Madrid.

1993 The Whitney Biennial marks the apotheosis of the trend for "identity politics."

1994 "Some went mad, some ran away…" at Serpentine Gallery, London; "L'Hiver de l"amour," Musée d'Art Moderne de la Ville de Paris.

1996 "L'Informe—mode d'emploi," Centre Pompidou; opening of Ars Electronica Museum, Linz, Austria.

1997 "Sensation" at Royal Academy of Arts, London ("challenging" **Young British Art** in a public space.)

1999 Brooklyn Museum, New York, shows "offensive" British art; mayor threatens to cut its city funding; Venice Biennale "dAPER-Tutto" ("[from] everywhere/open") highlights art (electronic-based, installations, videos) with a wider catchment area than ever before.

2000 Opening of Tate Modern, London, on time and within budget.

early 2001 Jérôme Sans and Nicolas Bourriaud appointed heads of the Palais de Tokyo, Paris, an exhibiting platform for "young artists."

1991 Civil war breaks out in Yugoslavia. Disbanding of the Warsaw Pact. America and allies begin military action against Iraq (the Gulf War).

1992 Convention on Biodiversity signed by 150 nations. Beginning of "ethnic cleansing" by Serbs in Balkan States.

1993 Czechoslovakia splits peaceably into Czech and Slovak Republics.

1994 Russian army invades autonomous region of Chechnya.

1996 Claims gather speed to recover property, including works of art, stolen by Nazis from Jewish families and deposited in Swiss banks.

1996 "Global warming" hypothesis widely accepted.

1997 Dolly, the genetically cloned sheep, is born.

1999 NATO begins military campaign against Serbia.

2000 Millennium computer bug fails to materialize as companies spend millions of dollars on counter measures.

2000 Overthrow of Milosevic heralds return of Yugoslavia to European fold.

2000 Human genome project completed: the sequence of human genes is now known.

Adam, P., *The Arts of the Third Reich*, London, 1992

Archer, Michael, *Art Since 1960*, London, 1997

Atkins, Robert, *Artspeak*, New York, 1997

The Avantgarde in Russia 1900–1930. New Perspectives (exh. cat.), Los Angeles County Museum of Art, 1980

Baigell, M., *American Scene: American Painting of the 1930s*, New York, 1974

Baker, K., *Minimalism*, New York, 1988

Battock, G., *Minimal Art. A Critical Anthology*, New York, 1968

Bocola, Sandro, *The Art of Modernism*, Munich/London/New York, 1999

British Art in the 20th Century (exh. cat.), Royal Academy of Arts, London, 1987

Britt, David, *Modern Art. Impressionism to Post-Modern*, Boston/London, 1989

Cardinal, R. *Outsider Art*, London, 1972

Chilvers, Ian, *Dictionary of 20th-Century Art*, Oxford, 1998

Cooper, M., and J. Sciorra, *R.I.P.: New York Spraycan Memorials*, London, 1994

Everitt, Anthony, *Abstract Expressionism*, London, 1975

Fath, M. (ed.), *Neue Sachlichkeit.* Munich, 1994

German Art in the 20th Century (exh. cat.), Royal Academy of Arts, London, 1986

Green, C., *Cubism and its Enemies: Modern Movements in French Art 1916–1928*, New Haven, 1987

Haftmann, Werner, *Painting in the 20th Century*, 2 vols., London, 1965

Italian Art in the 20th Century (exh. cat.), Royal Academy of Arts, London, 1989

Lincoln, L. (ed.), *German Realism of the Twenties: The Artist as Social Critic*, Minneapolis, 1980

Livingstone, M. (ed.), *Pop Art*, London, 1991

Joachimides, C. M., and N. Rosenthal (eds.), *American Art in the 20th Century*, Munich/London/New York, 1993

Kulterman, U., *Art-Events and Happenings*, New York, 1971

Lippard, L.R., *Six Years: The Dematerialization of the Art Object from 1966 to 1972*, New York, 1973

Lovejoy, M., *Postmodern Currents: Art in a Technological Age*, London, 1989

Lucie-Smith, Edward, *Lives of the Great 20th-Century Painters*, London, 1984

Lucie-Smith, Edward, *Movements in Modern Art since 1945*, London, 1969

Lucie-Smith, Edward, *Artoday*, London, 1995

McCloud, S., *Understanding Comics: the Invisible Art*, Northampton, MA, 1993

Muller, J-E., *The Dictionary of Expressionism*, London, 1973

Myers, Bernard S., *The German Expressionists: a Generation in Revolt*, New York, 1957

Nash, J. M., *Constructivism and Futurism*, London, 1974

Peiry, L., *L'art brut*, Paris, 1997

Popper, F., *Art of the Electronic Age*, London, 1993

Post-Impressionism (exh. cat.), Royal Academy of Arts, London, 1979

Prestel Dictionary of Art and Artists in the 20th Century, Munich/London/New York, 2000

Ratcliff, F., *Paul Signac and Color in Neo-Impressionism*, New York, 1992

Rodriguez, A., *A History of Mexican Mural Painting*, London, 1969

Rosenblum, Robert, *Cubism in 20th-Century Art*, London, 1960

Sembach, K.-J., *Art Nouveau: utopia, reconciling the irreconcilable*, Cologne, 1991

Shapiro, D., *Social Realism: Art as a Weapon*, New York, 1973

Tesch, J., and E. Hollmann, *Icons of Art: the 20th Century*, Munich/London/New York, 1997

Tibol, R., *Orozco, Siqueiros, Tamayo*, Mexico City, 1974

Vaughan James, C., *Soviet Socialist Realism: Origins and Theory*, London, 1973

Vogt, Paul, *The Blue Rider*, London, 1980

Photo Credits

© 2001 Prestel Verlag
Munich · London · New York

Prestel Verlag
Mandlstraße 26 · D-80802 Munich
Telephone: (089) 38 17 09 0
Fax: (089) 38 17 09 35
www.prestel.de

4 Bloomsbury Place
London
WC1A 2QA
Tel.: (020) 7323 5004
Fax.: (020) 7636 8004

175 Fifth Avenue, Suite 402
New York
NY 10010
Tel.: (212) 995 2720
Fax.: (212) 995 2733
www.prestel.com

Library of Congress Card Number:
00-110484

Prestel books are available worldwide. Please contact your nearest bookseller or any of the above addresses for information concerning your local distributor.

Editorial consultant: David Radzinowicz
Editing: Mary Scott
Translation from the German:
John W. Gabriel
Picture research: Melanie Pfaff
Design: Dorén und Köster, Berlin
Color separations: Repro Ludwig, Zell am See
Printed and bound by Clausen & Bosse, Leck

Printed in Germany

ISBN 3-7913-2221-4